CHESTER
in the 1960s
Ten Years that Changed a City

PAUL HURLEY

AMBERLEY

First published 2015

Amberley Publishing
The Hill, Stroud
Gloucestershire, GL5 4EP

www.amberley-books.com

British Library Cataloguing in Publication Data.
A catalogue record for this book is available from the British Library.

ISBN 978 1 4456 4103 4 (print)
ISBN 978 1 4456 4112 6 (ebook)

Typesetting and Origination by Amberley Publishing.
Printed in Great Britain.

Contents

Acknowledgements

This book could not have been compiled without the help of my good friend and respected Chester historian Len Morgan, who allowed me access to his large archive of photographs, history and anecdotes. I also benefitted from the assistance given by historian Steve Howe, who allowed me to dip into his excellent series of websites (www.chesterwalls.info) and sent me some photographs. If your interest lies in Chester's history then this website should definitely be in your list of favourites. I also thank Rachael Wheatley of Chester Zoo and Elizabeth Masters of Headline for kindly sending me a copy of the excellent book, *Our Zoo*, by June Mottershead; Peter Boughton FSA, the Keeper of Art at the Grosvenor Museum; and finally my wife Rose for her patience during the writing of the book and her attention to detail when proofreading it. Finally, I would like to thank my editor Dana Fowles for her help and hard work in getting the book ready for print.

Introduction

Following on from my last book, *Chester in the 1950s*, this book looks at the next decade. *Chester in the 1960s* gives an insight into the period in Chester's history that saw more physical change than ever before. In the country as a whole, and this obviously applies to Cheshire's own city and its residents, we enter the Swinging Sixties – a decade of great change in everything from the standard of living through to new technologies, music and fashions. At the start of the decade, televisions were mostly still small and in black and white, but with far more problems and glitches than we have today with digital televisions. Transistor radios became every teenager's must-have piece of equipment. This small plastic box did not need heavy and fragile valves or 10 minutes to warm up. As for the youth of the decade, their style of music had arrived. Radio Luxembourg boasted the most powerful radio transmitter in the world and, although it had been broadcasting since the 1930s, it came into its own in the late 1950s and then in the 1960s. Unlike the BBC, the station was in tune with what the 'hip' kids of the day wanted. They wanted rock and pop when all the BBC had to offer was music for their mums and dads. All over the country the younger generation listened to the station, which went out in the evenings; sometimes they listened with friends and sometimes under the bed covers with their new transistors. Who of a certain age cannot remember Horace Batchelor from Keynsham spelt K.e.y.n.s.h.a.m, Keynsham, Bristol, with his foolproof method of winning the football pools? Even then I wondered why he found it necessary to run his company when he could win all the money he needed.

Then along came the pirates; Pirate Radio was broadcasted from ships offshore and outside the Territorial limits. Radio Caroline was the first in 1964, quickly followed by Radio Scotland, and then others took advantage of this new way of broadcasting. Some radio sets of the period actually had Radio Caroline on the dial.

By 1967, the stations had grown massively in popularity, aided by the superb music of the decade. The conservatively run BBC decided to do something about it. A law was passed in parliament rendering the selling of advertising and services to an unlicensed radio station illegal. The better DJs were poached

to work on the new channel, BBC1 Radio, which was loosely based on another pirate, Radio London. The pirates limped on for a while, illegally and in the main un-funded, but still popular.

In the 1960s, pop and rock had truly landed; they were heralding a new youth-based society. A new way of talking developed, young women became 'chicks', and 'hip', 'cool man' and many other phrases were developed. As the decade progressed, out went men's suits and ties for everyday work and play, and in came casual clothes. For the teenage girl, long and flouncy frocks and skirts with stockings made way for miniskirts and tights. Also popular for young ladies were dresses, hats and outerwear made from shiny coloured PVC.

Beatniks had been around since the mid-1950s ('beatniks' or 'beat' meaning 'beaten down') after Jack Kerouac had introduced the title, 'The Beat Generation', in 1948. They arrived on the scene with their long hair, vibrantly coloured clothes and their own drug culture. They would later be copied in the grunge and punk movements of the later years of the century.

Teddy boys and girls gave way to mods – short for modernists – and rockers. Mods preferred motor scooters and anoraks bedecked with badges, their scooters having as many lights and mirrors that they could fit on the front, and Rockers had motorbikes and scruffy leathers, mainly British motorcycles that really sounded like true motorbikes. The rock band The Who were a great influence at the time. Needless to say, both groups liked to fight among themselves, preferably at seaside locations in the south.

The Beeching cuts came into effect and many small and not so small railway stations disappeared from the scene completely; some were turned into pleasant country walks, but most were rendered un-redeemable due to the imposition of supermarkets, industrial sites and housing estates. Common artistic posters such as the one shown here became a thing of the past.

This was the era when not only the railway infrastructure changed forever; steam engines were being replaced with diesels and electrics. August 1968 saw the last regular service train with steam power. Since then, steam has returned, but only on the few classic trains and in the many volunteer run private railway lines. No more will we see steam engines pulling regular trains on the main line.

Towards the end of the decade, another movement arrived, namely Flower Power. It originated during the anti-Vietnam War demonstrations as an example of passive resistance when flowers would be handed out by the newly named hippies. These hippies, who needless to say were 'hip', would wear flowery clothes with flowers in their hair. They frequented rock concerts, most notably Woodstock and Glastonbury. The movement started in the Haight

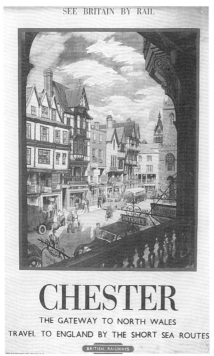

Chester British Railways Poster.

Ashbury area of San Francisco and quickly spread, aided by songs such as 'San Francisco (Be Sure to Wear Flowers in Your Hair)' by The Flower Pot Men, which came out during the 1967 'Summer of Love.' It became hip to take drugs like LSD, cannabis and heroin, and this became part of the movement and remained so through to the mid-1970s.

Students became more politically aware and were influenced by the CND marches to such places as The Aldermaston Weapons Research Establishment in Berkshire. CND had started in 1957 and reached its zenith in the mid-1960s, when its badge, now a universally acknowledged peace sign, became popular. The organisation wanted unilateral nuclear disarmament, which was not necessarily a popular ideal in the country as a whole – 'unilateral' meaning we should give up our nuclear deterrent, but other countries didn't have to. That would have been multilateral and that was not the aim of the liberal intelligentsia of the day or their student followers.

The opportunity for more civil disobedience was present in the 1960s, as the Vietnam War, which had started in the early 1950s, suddenly escalated. The United States and the South Vietnamese, who were fighting the Communist backed Viet Cong, stepped up their involvement. In 1961, the US tripled the number of troops on the ground, and, in 1962, they tripled them again. The

continuation of this war and its naked brutality, as seen on news bulletins, led to demonstrations across the world. The US involvement peaked in 1968, although the war did not actually end until 1975 with a North Vietnamese victory and US service personnel deaths amounting to 58,220.

The 1960s could be described as the decade where change permeated every aspect of peoples' rights. It heralded the birth of feminism, which demanded equal opportunities, rights and pay for women. At the time, 'the little woman' was still expected to remain a virgin until marriage, then stay at home and look after her husband. The word 'feminist' had been in existence since the 1800s, but in the 1960s, the newly formed Women's Liberation Movement ratcheted up the ideals and aims of women, and this led to demonstrations and a real demand for freedom and equal rights.

From the earliest days, homosexuality had been illegal and was punishable by hanging as late as the 1700s. Many iniquitous and unforgivable actions were taken against homosexuals; there is no better example of this than the action taken against Alan Turing – the man who contributed so much to the war effort with his work at Bletchley Park. Charged with the offence, he appeared in court in 1952 and was given the choice of prison or chemical castration; he accepted the latter. With his illustrious career in tatters, being barred from the USA and his work in Britain, he committed suicide at his home in Wilmslow in 1954. This was a high profile victim, but the debate was opened into the rights and wrongs of homosexuality being illegal. This eventually led to The Sexual Offences Act 1967, when limited freedoms were given to gay men. These freedoms introduced in the 1960s were expanded over the coming years.

Another 'ism' to raise its head was racism. Demonstrations started in the USA, where discrimination in certain states was still in existence in much the same way as apartheid was the rule in South Africa. Martin Luther King was a prominent leader of the African American Civil Rights Movement in the USA, until he was assassinated in Memphis Tennessee at the age of thirty-nine. In South Africa, the black population started to campaign against the state and its apartheid system. One of the leaders, Nelson Mandela, was arrested in 1962 and then served twenty-seven years in prison. Later, after apartheid was finally abolished in the 1990s, he became the internationally revered president of the country. But it will always be remembered that the 1960s was the era in which man first landed on the moon. On 20 July 1969, Neil Armstrong and Buzz Aldrin became the first humans to set foot on the moon. The Beatles, Rolling Stones and the many other bands also made the 1960s an iconic period for those who lived during it, and those who were yet to be born to look back on.

1

Chester in the 1960s

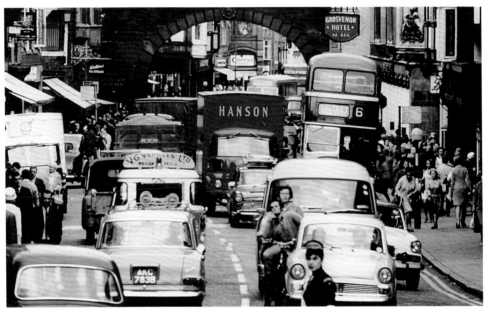

Eastgate Street, 1967.

The introduction was a brief look back at this period of change. In the rest of the world, it saw the building of the Berlin Wall, the assassination of the US President and the Cuba Crisis that many thought would start a third world war. But what about Chester? Well, the traffic was becoming a problem, as can be seen from this photograph of Eastgate Street.

This would be later alleviated by cutting a swath through the ancient city with an inner ring road. This necessitated widespread demolition of old properties, an act that was not totally appreciated by the residents, although the ease of passing through the city in a vehicle was perhaps later appreciated. The Cheshire Police headquarters were becoming too small for the growing police requirements and so a new building had to be planned. Then there was the rail network into the city with two stations. The 1960s would see this

change, and, of course, a city must have entertainment. Chester Zoo, one of the biggest and most famous in the world, reached a milestone in 1960; within and outside the walls, work continued to uncover and preserve the many historic sites. All in all, Chester recovered well from the deprivation inflicted on the country by the Second World War, mainly due to the fact that, as mentioned in *Chester in the 1950s*, little damage was done by Adolf and his Luftwaffe.

To end this brief overview of what is to come in the book, one occurrence that made Chester famous in the 1960s was not pleasant; it shocked the world. At the time, the town of Hyde was in Cheshire and home to Wardle Brook Avenue, which went down in the annals as a crime of the most heinous kind. I am talking of The Moors Murders of course, carried out by the truly evil Myra Hindley and Ian Brady. In the course of the investigation, a tape recording was recovered and the voice of a little girl could be heard screaming, crying and begging for her life. I know that hearing this tape, as I have done, will have affected everyone else who also had to hear it. Sickeningly, the music in the background was 'The Little Drummer Boy'. On 27 April 1966, Hindley and Brady appeared at Chester Assize Court as it was then known. Although they pleaded not guilty, they were duly convicted and sentenced to imprisonment. Fortunately or unfortunately, however you view it, they escaped the death penalty by only a couple of months as The Murder (Abolition of the Death Penalty) Act 1965 had come into effect just four weeks before their arrest.

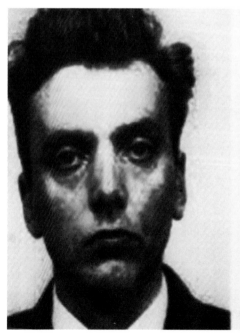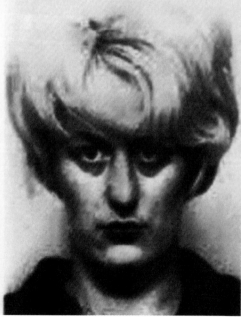

The Planning and Building of the Inner Ring Road

Although the planned route of the proposed inner ring road connected with Grosvenor Bridge, which already took far too much traffic, the government endorsed the scheme and paid three quarters of its construction costs of £1.2 million. Work started and the north-western section was opened in 1966. By 1972, the entire road had been completed. Although it improved traffic flow, its impact on the environment caused concern.

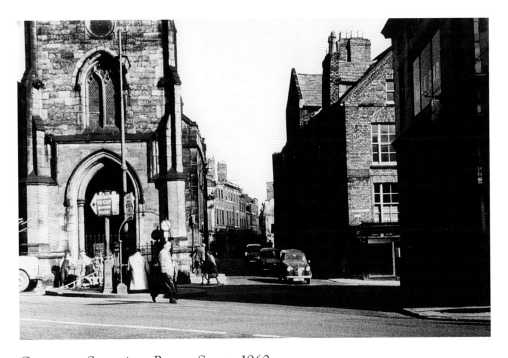

Grosvenor Street into Pepper Street, 1960s
Here we see the junction with Grosvenor Street, Pepper Street and Lower Bridge Street as it had been for years. Below is an example of the work in progress to build the ring road.

Demolition of the Ring Road

This is the sort of demolition that would be needed to enable the ring road to pass through the city. Here, Grosvenor Street, Pepper Street and Lower Bridge Street are being altered as Grosvenor Street is widened to take the new carriageway. The main developments in planning, rebuilding and conservation did not really begin until after 1960, but by the end of the reconstruction, the appearance of much of the city centre within and just beyond the walls had changed radically. New suburbs such as Blacon and The Lache had spread far to the west and north of the older built up area.

Eastgate Street in the 1960s

The traffic in Eastgate Street, as seen here, could not continue and this was one of the first roads to be bypassed. As a result, a major element in the council's plans was the completion of inner and outer ring roads, since it was acknowledged that the solution of the traffic problem would determine whether Chester remained a regional centre. The outer ring road remained incomplete, notably south of the city, where a new bridge across the Dee was urgently needed.

The inner ring road had its origins in the widening of Little St John Street in 1938. In 1962, after abandoning a proposal to widen Northgate Street, the council adopted a scheme that connected Little St John Street, Pepper Street, and Grosvenor Street to a new roundabout north of the castle. So onwards we go, along Grosvenor Street towards the castle and the new roundabout that would take traffic off the Grosvenor bridge and into the shopping areas, or along the ring road to a new roundabout at the top of Nicholas Street. The photograph opposite is of the roundabout in 2014.

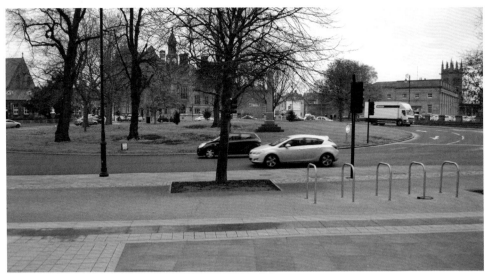

Castle Roundabout in 2014.

In the photograph below from 1964, we see the construction of the inner ring road in Nicholas Street. It gives a good illustration of just how many buildings were to go and what a different place Chester would become on completion of this major reconstruction. It would, however, be the 1970s before the Castle Inn (seen in the next photograph) was demolished for modern development. The main work in Nicholas Street involved widening it by removing the buildings on the right looking at this photograph.

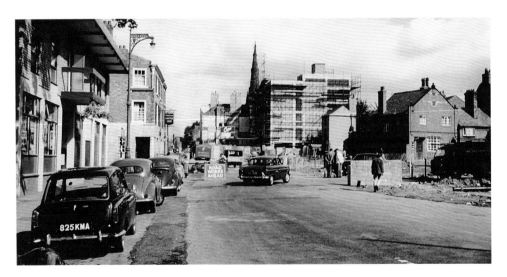

Nicholas Street, 1964

The road then ran north along a widened Nicholas Street and Linenhall Street, and again the road was altered and buildings demolished. Some demolition, such as that of the Castle Inn (*above*), had nothing to do with the road and more to do with modernisation. The same applies to buildings like the one shown in the next photograph with its eclectic mix of vehicles: a Rover P4 police car, an Austin Devon and a Humber with an ancient hand cart at the rear. These buildings were later demolished and replaced with a modern building.

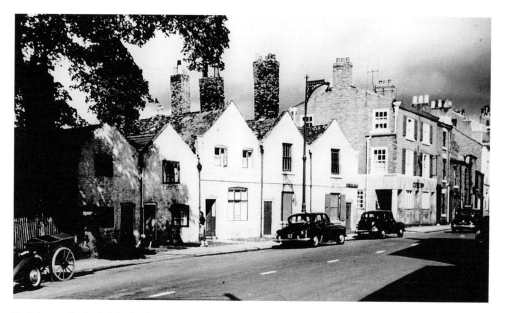

St Martin's Ash Nicholas Street, *c.* 1960, now Tory HQ

St Martin's church was sacrificed, along with Georgian houses on the east side of Nicholas Street and Egerton House on Upper Northgate Street, regarded by some as among the city's best Georgian buildings. In addition, the new viaduct was thought obtrusive; the way in which the new road separated the city centre from the Dee was widely condemned. There were doubts about the impact of the concrete multi-storey car parks built as part of the scheme. In fact, in all new buildings concrete was subject to a lot of verbal abuse.

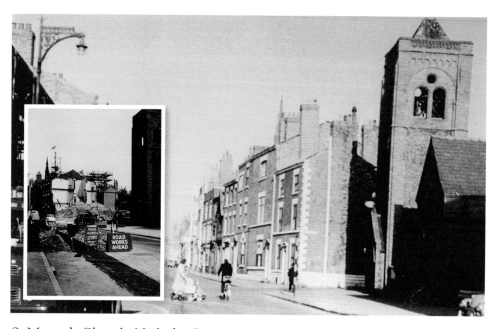

St Martin's Church, Nicholas Street, 1962
Inset: Nicholas Street, Cuppin Street Whitefriars and St Martin's Church, 1962

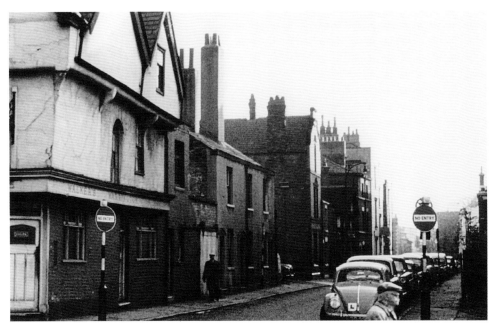

Looking Along Nicholas Street from the Old Yacht Inn, 1963

The northern city wall was breached to make St Martin's Gate, which allowed the Chester Wall to cross over the new St Martin's Way dual carriageway. This footbridge was designed by the city engineer and surveyor A. H. F. Jiggens in consultation with G. Grenfell Baines, and with approval from the Royal Fine Arts Commission. St Martin's Gate and the new viaduct were formally opened on 22 April 1966 by the Minister of Transport, Mrs Barbara Castle. A plaque was unveiled on the wall at the side of the gate, as can be seen in this photograph.

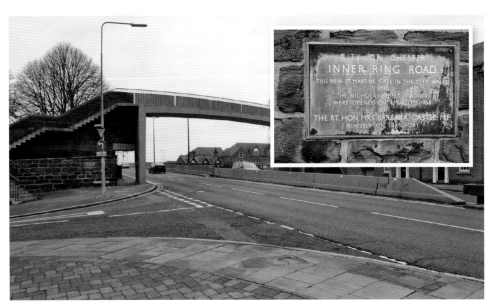

St Martin's Gate Today

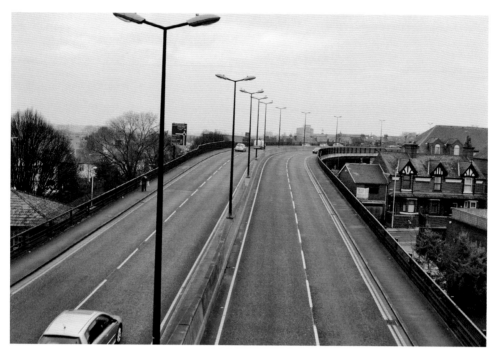

New Viaduct

Carrying on along a much-widened Nicholas Street and after the junction with Watergate Street, the road becomes St Martin's Way. The road swings eastwards outside the walls on an elevated viaduct. This viaduct lifted the road and continued until it reached what is now known as the Fountains roundabout. This was taken during the final stages of building the roundabout.

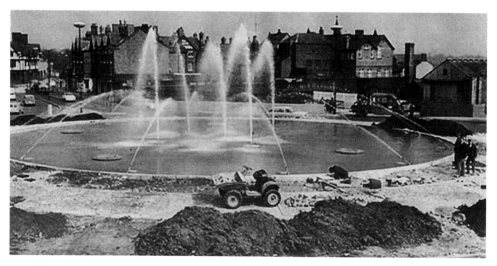

Building the Fountains Roundabout

The erection of this large roundabout meant losing some more old Chester buildings, but allowed the inner ring road to continue down St Oswald's Way and link up with Upper Northgate Street, Liverpool Road and Parkgate Road. One of these lost buildings was the very attractive Egerton House that stood in Upper Northgate Street, right at the new location of the Fountains roundabout.

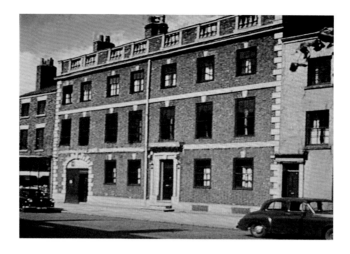

Egerton House, Upper Northgate Street, 1960

Let us use this opportunity to look inside Egerton House, to give us an example of the many superb buildings that were lost in the building of the inner ring road.

Egerton House was a major casualty of the inner ring road. The elegant house (*c.* 1730) in Upper Northgate Street was built for Sir Philip Egerton, whose family seat was Oulton Hall in Little Budworth.

A 1947 review of the building described it as a large eighteenth-century property consisting of three storeys and a carriage entrance on its left-hand side. A second property believed to have been owned by the Egerton family, and bearing the same name, reportedly existed at one time at the eastern end of Foregate Street, near to the area known as The Barrs.

After the roundabout was completed with its attractive fountains, if only seen working intermittently, the road continued down, becoming St Oswald's Way. At the Hoole Road junction another large roundabout was built, covering what became Hoole Way into Brook Street and across the railway line into Hoole Road on one side. This required more extensive demolition of buildings in the ancient Brook Street. Here we have two photographs of another attractive building that was demolished, as were all of the buildings around it.

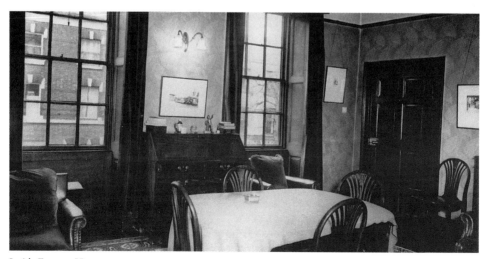

Inside Egerton House.

Milton Street and Brook Street, All Demolished for the Ring Road in 1962

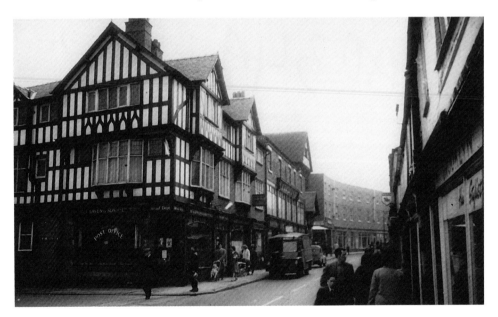

Milton Street and Brook Street from a Different Angle

On the opposite side of the roundabout is Cow Lane Bridge, leading to Frodsham Street. This was reached by crossing the site of the cattle market at the Gorse Stacks. The cattle market was taken to a new site at Sealand Road in 1970. There was little in the way of objection to this, as, in the past, cattle had been driven from there to the railway stations, causing traffic problems and inconveniencing pedestrians. Therefore, this change was a distinct improvement and attracted few complaints. Eventually Gorse Stacks, once the home of bundles of gorse, would become a large car park. Plans are afoot, however, to remodel this area once again.

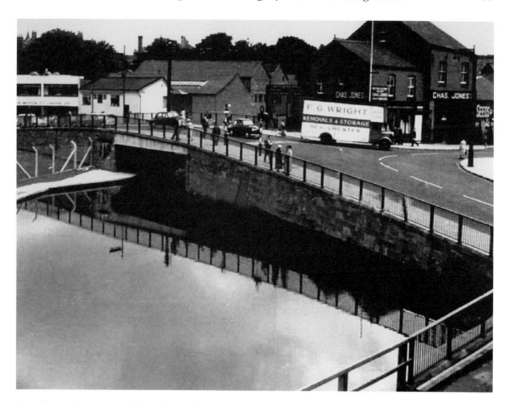

Looking Down on Cow Lane Bridge

The Cow Lane Bridge across to Frodsham Street was widened and rebuilt in 1969. After the Hoole roundabout, St Oswald's Way was continued, partly on another viaduct across the canal and to another major roundabout junction at City Road. This was then continued along a widened and one way Bath Street, and to Little John Street from whence it started. On the way there, other buildings and streets had to be thinned out or demolished altogether. The roundabout linked City Road with Foregate Street, an area requiring the demolition of many buildings to form the new roundabout (if in fact it can be called a roundabout, being big enough to house a large office block).

In order to cross this road network safely, a series of underpasses were constructed with several entries and exits. One of the buildings sacrificed for this underpass was the black-and-white building next to the old police headquarters at the junction with Foregate Street and Grosvenor Park Road. This area is known as The Barrs; the name goes back to a strong postern gate that once separated Foregate Street from Boughton. It has been carried down through the centuries and still exists today.

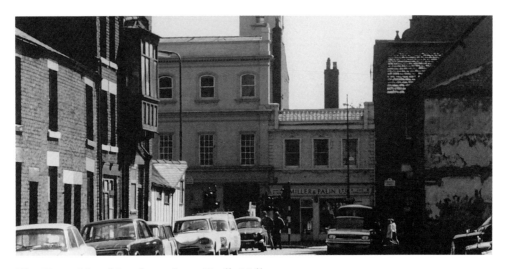

The Barrs Hotel Looking from Earl's Villas

Most of the buildings in this photograph have now gone to make way for the large City Road roundabout on one side and Foregate Street opposite. This area underwent massive changes, leaving a large building in the centre of the roundabout and a detailed underpass system to take pedestrians from Foregate Street to City Road and the other roads off the roundabout.

Seller Street also enjoyed the attentions of the bulldozers; before buildings were demolished they were boarded up. This can be seen in this 1963 photograph at the junction of City Road.

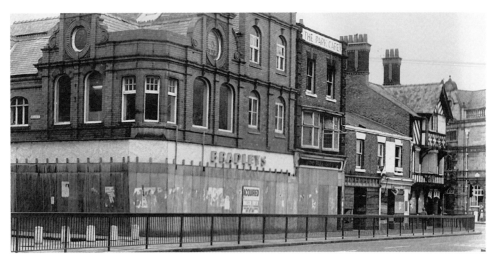

Foregate Street, Seller Street and City Road (*Far Right*), 1963

The large and impressive building that is boarded up was, for a long time, the home of Bradley's outfitters. This business began as a pawnbroking business in Brook Street and was founded in 1878 by Mr William Bradley. In 1882, an outfitting business opened in Foregate Street and these new premises were built on the corner of Seller Street. The junction of Seller Street and Foregate Street became known as Bradley's Corner. Branches were opened in other towns, and wholesale warehouses and a clothing factory were established before the First World War. Anthony Bradley died in 1908 and the business was acquired by one Joseph Banks. In 1927, new headquarters opened in City Road, which then closed in 1971.

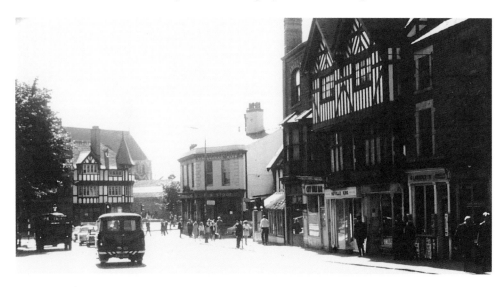

City Road

All of the buildings here have gone to make way for the ring road, except St Werburgh's church, which can be seen in the distance. In this photograph we see City Road in 1969 before all of these buildings were demolished.

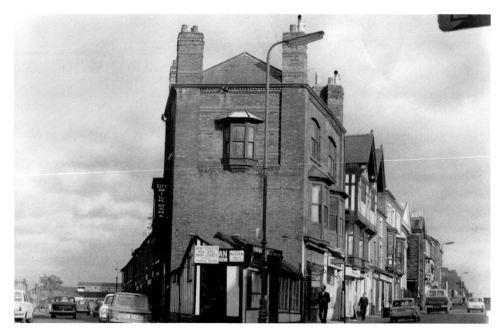

City Road and Earl's Villas, 1969

The picture shows the St Oswald's Way section before demolition began. Now high-rise flats dominate the skyline. They are not the most attractive of new developments and there are three, named after the streets that they are in – namely St Annes, St Oswald's and St George. They replaced older housing in the Newtown area. In the photograph, Earl's Villas can be seen on the left and on the right is City Road with the old City Milk Bar. Further up City Road is the old Royalty Theatre that we will feature later in the book, then of course Chester station.

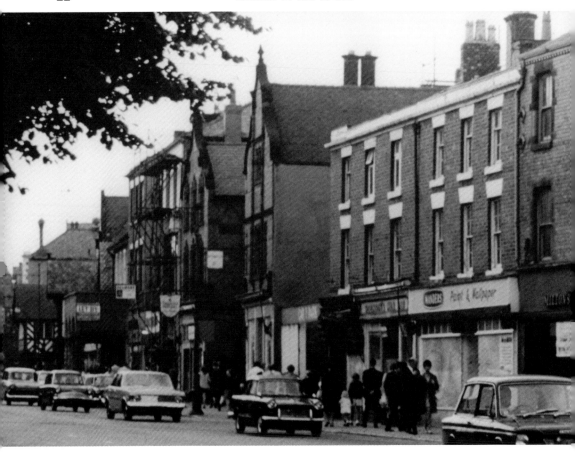

Foregate Street Near City Road

As well as the inner ring road, an outer ring road was also planned. The problem of traffic in and around Chester was recognised as early as the 1930s, when a plan was drawn up for an outer ring road and the northern sector was completed. Nothing more was done until the 1950s when the local MP, Mr John Temple, petitioned for one to be built. When speaking in parliament in favour of the outer ring road, he quoted from a letter written by the secretary of Crosville Motor Services saying,

> We now look upon Chester as the blackest spot in the whole of our operating area which, as you know, extends over seven counties … the result of this traffic congestion is catastrophic.

Despite this, nothing major commenced, but over the next few years a piecemeal outer ring road came into being without the major effects on the infrastructure caused by the building of the inner ring road. As well as the inner and outer ring roads there was a lot more for the council to do to modernise the ancient city of Chester. Immediately west of the town, slum houses had been demolished in the 1930s and the area left derelict. By 1945, Chester's City Engineer and Surveyor was a rather efficient gentleman who went by the name of Charles Greenwood; he investigated and prepared a redevelopment plan. This plan attempted to bring together both economical and cultural considerations. It was an attempt to give both sides of any prospective objections an answer that they would be content with. We will look at this plan in more detail later.

3

A Look at the Old and New Market

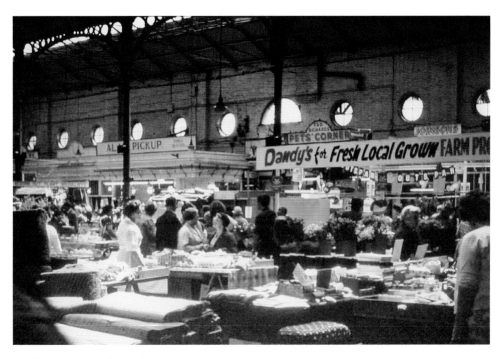

Stalls in the Old Market

The Chester Market Hall closed its doors for the final time on 17 June 1967, after serving generations of shoppers from a wide area for more than a century. With its architecturally heavy stone façade it was – and in fact it looked like – a solid Victorian marketplace, typical of so many built throughout Britain in the nineteenth century. Affection for it was warm and widespread, and nostalgia for the friendly old market will remain with many Cestrians long after new shopping habits have been formed.

Over the years, markets have been seen as the hub of the community – a place where farmers could sell their products, where stalls could be rented cheaper than shops, and where people would meet and chat while shopping for the table and everything else that was needed. Chester Market was no exception; for centuries it played a central role in the business and cultural life of the city. A regular market had taken place in and around this area since at least 1139. The farmers and country folk would drive their livestock and carry their goods into the town, and many set up their stalls in what has long been known as Market Square, but now more commonly Town Hall Square, Northgate Street.

Chester Market Hall Front, 1960s

Originally, market stalls were also situated randomly around the city. This was not ideal and had to change. Chester Market Hall, which can be seen in the photograph, was built in a warm cream sandstone in baroque revival style in 1863, replacing three venerable inns that had long occupied its site. Two years later, the town hall adjoining it was built in the same style and looked as if it were one building. It harmonised wonderfully. These adjoining buildings certainly added to the general Chester ambience and could not be found fault with.

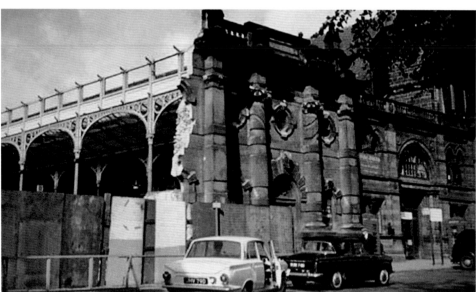

Demolition of the Old Market Hall

In 1967, this building was demolished to the disgust of many Cestrians, leaving an empty space to be filled with more 1960s tat. It was an era that has a lot to answer for in respect of what can be described as 'the building of carbuncles'. Only, in this case, we are not talking of a brown belt site in an industrial city, but the centre of one of the most beautiful cities in England. A building was built that is now being replaced itself, unlike the original Market Hall, which traded for 100 years. Here is a photograph of the demolition in progress.

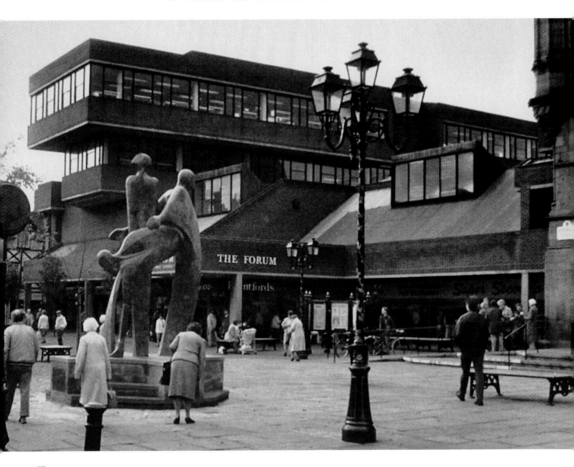

Forum

This photograph shows the replacement for the Market Hall, the Forum shopping centre and offices. This building was designed by Michael Lyell and Associates; even on completion it was felt to be extremely ugly and certainly did not fit into the ancient city, opposite one of the most splendid cathedrals in the country. So much so in fact that it was partly demolished itself just twenty-five years later in 1995.

The next photograph (*overleaf*) is of the Forum as it looks in 2014, albeit with a Christmas market in progress in front of it. Just why (as in the case of the coachworks that we will see details of shortly) could they not have retained the very attractive front elevation and rebuilt the rear just as modernly as they felt comfortable with? Luckily, they were not allowed to demolish the town hall or coachworks in the same way, so I suppose we have small mercies to be thankful for. The first fantastically designed Forum never lasted quite so long as its predecessor, the old Market Hall.

As the Forum Looks Today

Back to Charles Greenwoods' plan in 1945. He attempted to reconcile the financial and aesthetic considerations. It was alleged that the Victorian public market no longer complied with hygiene regulations and so an excuse was found for its demolition and redevelopment. Greenwood proposed that as well as council offices and a new market, there could also be a civic centre with a new central library, a museum and art gallery, and a concert hall. A scheme based on this plan was approved by the government in 1952, but not put into effect until 1958. The council added a bus station to its requirements, and in 1960 invited private developers to submit schemes. The brief was for an extension to the town hall, a general market with suitable car parking and sites for private development. The council appointed G. Grenfell Baines as its planning consultant, and, in 1961, a scheme was accepted on his recommendation. This was for the building of the Forum.

The architects were Michael Lyell & Associates. The city owned the land and was excused the cost of the new development; it ceded most of the profits to private enterprise. The inner ring road, which was to run along the western edge of the new Forum, required access to parking beneath the new market hall. A new bus station was also required. In 1961, G. Grenfell Baines recommended that the plan involved 'sound and imaginative town planning, expressed in good modern architecture'. He accepted the scheme, the Forum, by Michael Lyell & Associates.

In 1964, Grenfell Baines produced planning guidelines for the whole city centre, but the first phase of Michael Lyell and Associates' scheme, the market hall, was delayed until 1967 because of archaeological work. Beneath the site of the new Forum were important Roman remains in a particularly good state of preservation. Only the market hall retained the boxy design of Lyell's original scheme; the final phase, which included council offices and a shopping mall, was delayed by further excavation until 1969–72 and was characterised by what were described as the 'Brutalist brick-clad forms' made fashionable in the early 1960s by the architect James Stirling. It had council offices boldly cantilevered over the Northgate Street entrance to the shopping mall, and was widely hated from the start. Office blocks were built speculatively nearby, but no attempt was made to integrate them with the Forum.

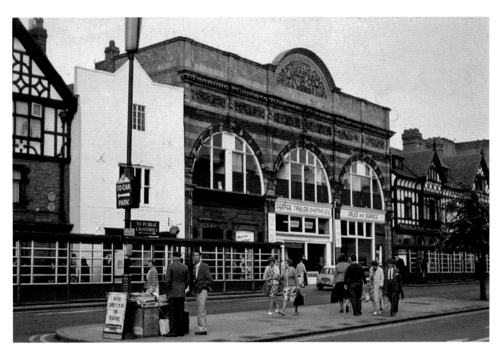

Coachworks, 1967

The original bus station was situated beside the attractive terracotta and red-brick Westminster Coach and Motor Car Works in Northgate Street, a building with its elaborately moulded terracotta and red-brick façade. Many times in my childhood, we would get the bus from Northwich and change here for Chester Zoo. This most attractive of buildings was built in 1913 to a design by Philip Lockwood, to house the coach building workshops and motor showroom. It was rebuilt in 1981–84, retaining the original façade, and became the new home of the library. The first public library in Chester appears to have been the City Library in Whitefriars, which dates back to 1773. A new bus station was constructed in nearby Princess Street, with access to the new ring road in St Martin's Way.

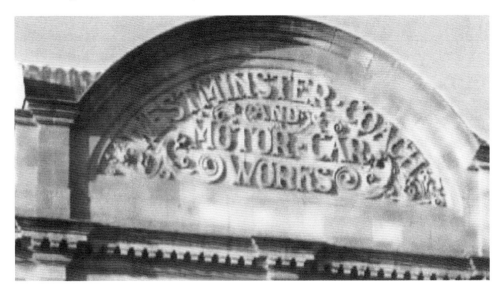

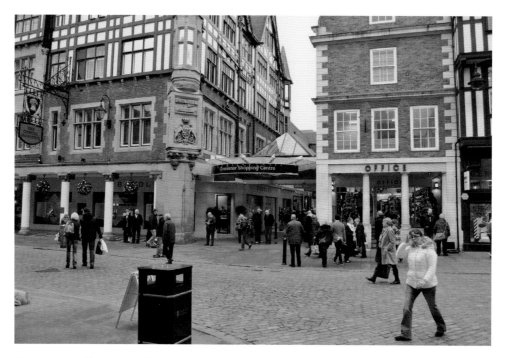

Grosvenor Shopping Centre

Multi-level planning similar to the first Forum design was used by the Grosvenor-Laing property company for the Grosvenor Centre, on 3½ acres owned by the Grosvenor estate between Bridge Street, Eastgate Street, Pepper Street, and Newgate Street. The last was blocked by the multi-storey car park and the Browns of Chester department store that was incorporated into the scheme.

The design of 1963, by Sir Percy Thomas and Son, was an early example of the tendency in historic towns to hide bulky new shopping centres behind existing buildings. It left the Rows almost intact, including a new block along Eastgate Street that was separately designed after the fashion of the Rows by Gordon Jeeves in 1962. Accordingly, another new and dedicated shopping precinct was built between Eastgate Street and Pepper Street, and called the Grosvenor Shopping Centre (above in 2014). New buildings were exposed only to the rear, where a multi-storey car park faced the Newgate and Newgate Street, and on Pepper Street, which received a long concrete-clad façade (a photograph of this can be seen further on).

The scheme incorporated the early twentieth-century St Michael's Row and the Grosvenor Hotel, which was extensively refurbished and extended in accordance with its boast of being Chester's premier hotel. Sixty new shops were provided, as well as office and conference facilities. It took only two years to complete, compared with the twelve years that building the Forum took. When opened in 1964, it was estimated that it would contribute greatly to the rates. This massive new shopping centre in the heart of the city was built in such a way that the only intrusion into the ancient Rows was the (not unattractive) gateway on view from Eastgate Street. It was designed by the architect Sir Percy Thomas and Son. Under the circumstances, it was design at its best.

What Else Was Swept Away and Perhaps Not?

Chester Infirmary

The infirmary was Chester's main hospital during the 1960s. The new Chester General Infirmary building was built between 1758 and 1761, and was opened on 17 March 1761. This was the period when a number of individual town houses in the city were being overtaken by wholesale redevelopment projects, such as Abbey Square. Previously open land within the walls soon began to be filled with housing and other individual buildings, and therefore Chester soon became a prosperous and fashionable provincial town with substantial Georgian houses.

The early Georgian period developed and saw new hospitals built in most of England's provincial towns; this was the era of the Georgian hospital movement. As a result of this, twenty-four new hospitals were built between 1750 and 1783, and the new Chester General Infirmary was one of them. The infirmary was one of the most progressive hospitals of its time. In its plan, the new infirmary was a quadrangle building, four storeys high and facing west, overlooking the River Dee and Welsh hills. According to old plans, there was an open central courtyard 54 feet by 42 giving light and air to the wards. The main wards ran the whole length of the building on the north and south sides; they were originally designed to take twenty-four beds each. On the remaining sides were staircases, a chapel and four small rooms for staff.

The infirmary accommodated 100 beds, affording about 1,000 cubic feet of air space per patient. The foundation stone for the new Albert Ward Wing was laid in 1912, and it was opened by King George V and Queen Mary on 25 March 1914 during a visit to Chester. At the same time, the King declared that the hospital should in future be known as the Chester Royal Infirmary. From this date, the infirmary was allowed to use the Royal prefix.

It was not until the early 1960s that a new outpatients and accident unit was constructed, with a visitors car park on the remaining area of the field. This new unit was opened by HRH Princess Marina Duchess of Kent on 11 June 1963. For the next thirty years, small-scale developments such as new theatre suites, an intensive care unit and engineering workshops were constructed together with various improvement works that were maintained on a piecemeal basis. The original building of the Chester Royal Infirmary was the main acute hospital in Chester on the same site for 232 years until its inpatient work was transferred to the Countess of Chester hospital in 1993. The infirmary was closed for good when the post-war outpatients department was transferred in 1996. The oldest part of the original hospital building has been retained and converted into apartments, called the 1761 development – the original opening date of the hospital. Almost all of the remaining hospital buildings have been demolished and replaced with houses and flats known as St Martin's Way.

Other Developments

During the 1960s, a handful of relatively small, cautiously modern commercial buildings were erected on sites that were architecturally sensitive and not really in keeping with their surroundings. For example, the one built in 1963 in Northgate Street, and another of higher quality in Watergate Street. By the mid-1960s, the area within the walls was virtually devoid of residents and consequently there was a need to introduce some dwellings.

At night, the city centre was mainly empty and prey to vandals, and the planners began to advocate the provision of new residential accommodation. The lack of residents also meant that some churches became redundant and were closed. These included the ancient parish church of Holy Trinity, which served most of the township of Blacon-cum-Crabwall, and part of the city of Chester. In 1960 the church was closed. On 21 December 1960, the church of Holy Trinity without-the-walls was built to replace it and two other churches, St Oswald and Great Saughall. The church of Little St John was transferred to duties outside religion in 1967 and St Martin's church closed in 1963. The methodists rationalised their circuits in 1963 and closed city-centre chapels in Hunter Street and George Street in 1967 and 1970. Among the other main denominations, the congregationalists did not rebuild their chapel in Queen Street after it was destroyed by fire in 1963, and left the Upper Northgate Street chapel in 1967. The unitarians replaced the Matthew Henry chapel, a victim of the inner-city redevelopment scheme in 1962, with a chapel in Blacon.

The Catholic Apostolic Church

Members of the Catholic Apostolic church worshipped in a room over the post office in St John Street, before opening a church in 1868 at the corner of Lorne Street and Church Street, off Garden Lane. The church, which was designed in an early English style of red brick with bands of blue brick and stone, held daily services in 1871. The building was sold in 1952 and demolished to make way for the inner ring road in 1964.

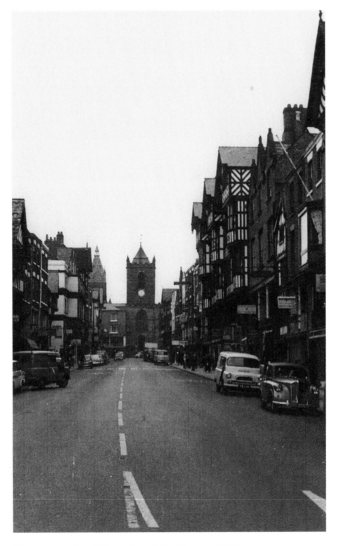

Bridge Street Showing the Church of St Peter, 1961

Here we have one of the many churches that have remained – well, the building has anyway. This is the church of St Peter, which looks down serenely into Upper Bridge Street and has done since it was built on the site of part of the Roman Praetorium, the headquarters building. Some of its fabric dates from that time. A church is said to have been built on this site by Aethelfleda in 907, then known as St Peter & St Paul, and is Chester's oldest church. The present church has modifications from the fourteenth century onwards, however. In 1086 it was referred to in the Domesday Book as 'Templum Sancti Petri'.

Note the church clock; there has been a clock on the tower since 1579 when one was purchased for the sum of 2s 6d and it had to be regularly wound. In 1736, it was illuminated by gas, and in 1855, the council took over the job of illuminating it. It was only in 1973 that the need to wind it by hand ceased and electricity took over. Today, the building contains a café and some ancient points of interest, together with a quiet room for contemplation.

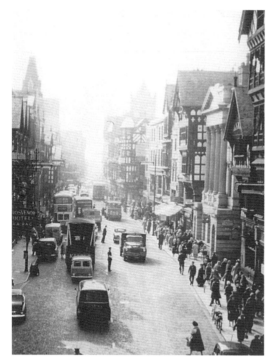

In Eastgate Street

Here we see Eastgate Street, with the sun shining down on the busy scene. This was taken from the clock above the Eastgate in 1967. It looks towards The Cross, albeit that the cross would not be replaced for another eight years. Chester was and still is an important tourist destination, and, in 1962, the Civic Trust, which was founded in 1959 to heighten public awareness of Chester's character, history, and civic design, initiated a plan to improve the appearance of the main streets. Owners and traders were persuaded to finance the refurbishment of their properties to an overall design, and to remove or replace unsightly signs. The council paid the fees of an architect to prepare the design and oversee its execution.

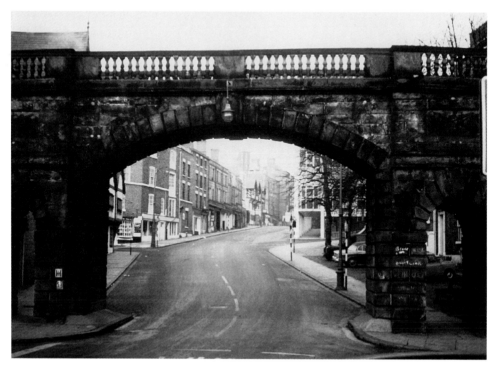

Bridgegate, 1964

Here we look through Bridgegate, up Lower Bridge Street towards the Falcon and the buildings beyond it that were soon to be demolished.

Bridge Street Improvement Scheme of 1964

1964 saw the experts and architects in Bridge Street contemplating the next moves in beautifying the city. In 1966, the first scheme for Bridge Street was judged a success, and Eastgate Street then received similar treatment. The radical transformation of the city centre during the 1960s and the changes that were involved were not welcomed by all; there was a conflict between growth and environmental quality. This led to heightened tensions between those who opposed change and those who sought it. Historians *vs* modernists – not an unusual dispute. Many of Chester's residents considered the historic city to be essentially medieval and this may have been the reason that they were comfortable with the loss of Georgian and Victorian buildings. They preferred the faux half-timbered version of the black-and-white domestic revival style, as shown below.

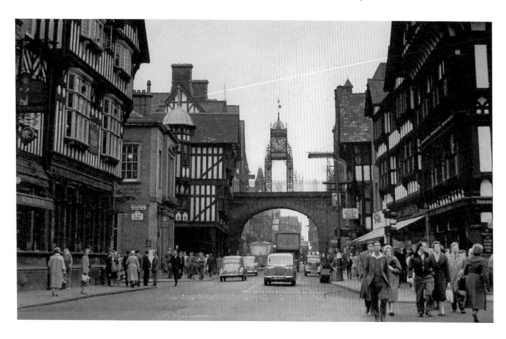

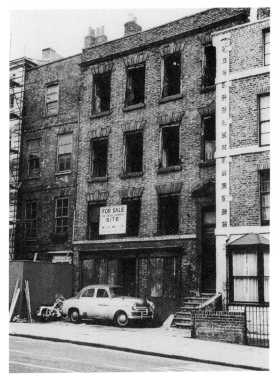

Lower Bridge Street, Liverpool House, 1960 and 2010

This sad-looking building (*above*) was to be renovated to a high standard, which I believe was quite beyond criticism and serves as an example of the fact that Chester fared better than a lot of towns and cities despite the odd carbuncle. Below is how the building looked in 2010.

In the past, the council of the day, to their shame, did very little to preserve Chester's genuine historic buildings. By the 1940s, much of the Rows were in very poor repair and Lower Bridge Street could almost be described as a slum. By 1955, property in Watergate Street had been bought by the council to protect it. It wasn't protected, but destroyed on the grounds that it had deteriorated beyond repair – that old chestnut constantly put forth as an excuse to demolish and not upgrade.

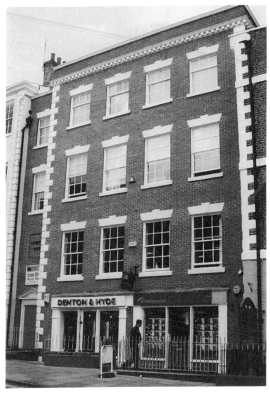

Watergate Street

Now for an example of a replacement building that a lot of the locals did not deem a fitting replacement for the buildings that had been demolished to make way for it, and would have much preferred some more Cheshire black-and-white buildings. This building is in Watergate Street and replaces one that went by the name of Uncle Tom's Cabin, which can be seen below. In the long distant past this was a pub by that name, later changing to the Leeswood Arms. However, this reckless demolition of Chester's heritage became known as The Gap and was a constant embarrassment to the council. Accordingly, in 1963, they organised a competition for an infill design and this was won by Herbert J. Rowse & Harker. Their block of shops and offices was designed as a Row in a contemporary style with flat-roofed cantilevered bays and exposed concrete. It remained unfinished, however, until the late 1960s.

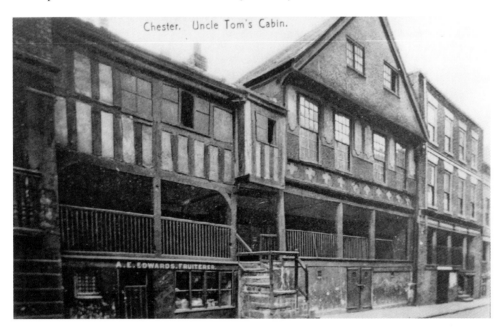

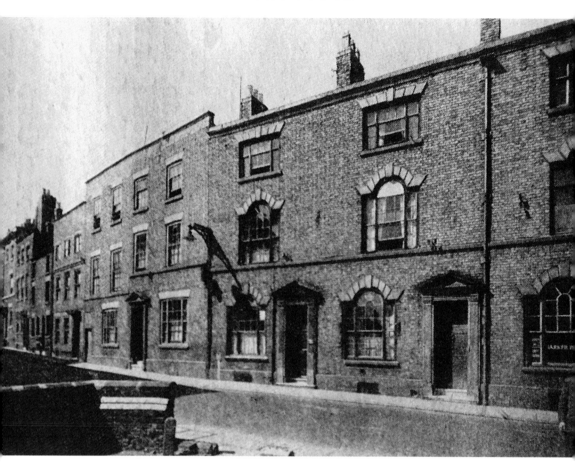

Pepper Street, 1961

This is a good example of the old as opposed to the new. One that is, in my humble opinion, not one of the best examples of architectural vandalism, as the old Pepper Street row could have been renovated. It was in a poor state, but it was close to one of the major scenes of alterations made for the inner ring road. Next we see the building that replaced it.

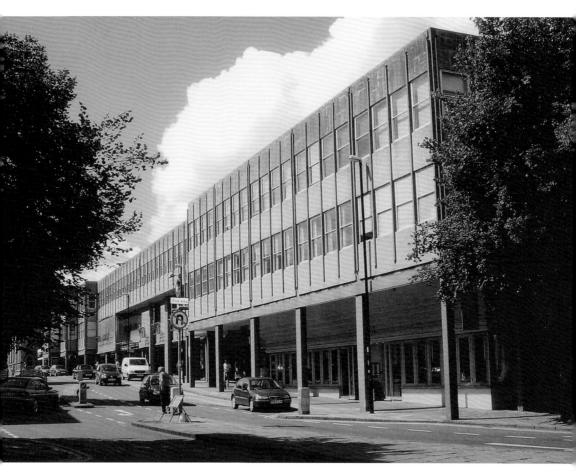

Pepper Street, 2010

Not too bad? I leave it to you to decide. It now has access into the Grosvenor Centre that the old building could not have. Successive councils proved unwilling to spend money on conservation. In 1959, for example, the corporation announced that The Blue Bell at 63–65 Northgate Street, which dates back to the mid to late fifteenth century, was in such a poor state that it was to be pulled down. The ensuing campaign ended when the government refused to permit demolition; in the early 1960s, the corporation had to spend £2,500 on preserving the building. This ancient pub has the pavement running through the ground floor storey of the building. It originally consisted of two medieval houses that were joined together in the eighteenth century. Thanks to that fight, it is still there now, has not fallen down and is a successful restaurant.

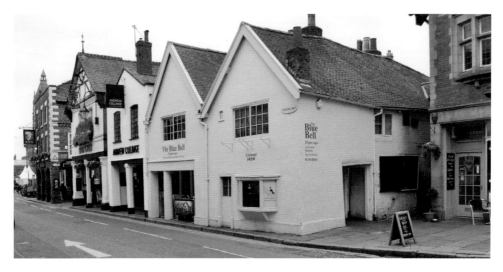

The Blue Bell

By 1966, public opinion was changing and the council was persuaded to abandon its plans to destroy Georgian houses in Queen Street. It agreed to renovate the Nine Houses in Park Street rather than demolish them. These houses are the only surviving fifteenth-century almshouses in Chester, having been built around 1650. By 1960, the houses were in a poor state, as can be seen by this photograph of the rear of them with the bulging walls and flying buttresses. Campaigns were set up locally to preserve them, and, in 1962, an architect was appointed to convert the row of houses into a folk museum.

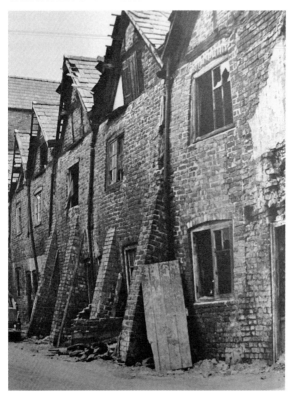

Nine Houses at the Rear

By this time, all of the tenants had been rehoused. The city council asked for plans to be prepared outlining other uses for the houses, including full modernisation so people could live in them. In 1964, a report was prepared for the Society for the Protection of Ancient Buildings, and, by 1966, the buildings were in such a sorry state of repair that their future looked bleak. After being awarded a grant of £5,500 from the Historic Buildings Council in 1968, Chester City Council agreed to renovate and rebuild them. Although known as the Nine Houses, only six remained. As can be seen in the modern photograph opposite, the row is now a very attractive sight that greets walkers on the city walls overlooking them. They also provide a good standard of living for the people residing in them.

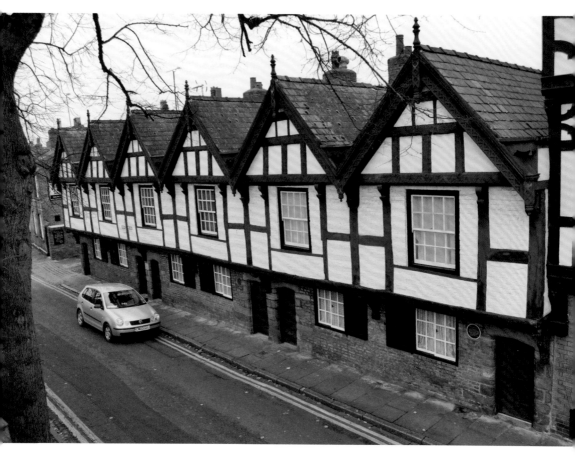

Nine Houses, 2014

It is doubtful whether conservation on a serious scale could have begun without extensive help from government funds. In 1966, Richard Crossman, Minister of Housing and Local Government, commissioned a pilot study of five towns of special historic importance. They were Bath, Chester, King's Lynn, Chichester and York. His aim was 'to show how town centre development in historic towns can be combined with the preservation of ancient buildings.' The number of towns was reduced to four when the projected study of King's Lynn failed to get off the ground.

Investigated were the special problems such places faced in relation to their modern development. The study led to the formulation of a national policy on conservation and this had extremely important consequences for many historic towns and cities. Donald Insall was nominated by Crossman to carry out the Chester study, which was a watershed in the history of conservation in the city. The content and status of his report with the weight of central government behind it changed the council's attitude. The crucial factor was the availability of central government funds for conservation. The Insall Report dealt with all aspects of town planning, from traffic management to tree planting, in relation to the city's historic fabric. It asserted that the restoration of old buildings could enhance both their own value and that of the whole city centre, and provided a feasible fifteen-year programme that identified the buildings most in need of saving. The ministry established a preservation group headed by Lord Kennet and included the noted architectural historian Nikolaus Pevsner. All in all, this government-backed pilot study would have far-reaching effects where conservation was concerned. For the first time it was taken seriously and the findings were accepted in the main.

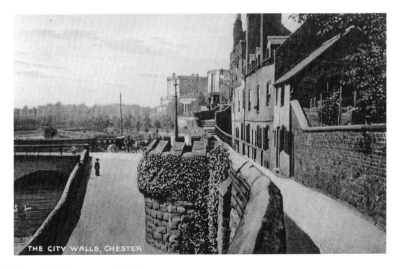

City Walls at Bridgegate, 1912

The city walls are the city's most important tourist attraction, yet despite proposals by Greenwood in 1945 and Grenfell Baines in 1964, the council failed to ensure that their surroundings were cleared and landscaped. Their very survival was always in question, for the type of stone that was used to build them made them expensive to conserve and repair. Only after the Insall Report of 1968 were the walkways even cleaned efficiently. This report gave the council the kick that they needed to preserve Chester for the future, and to preserve and restore the city's historic fabric. The council's Director of Technical Services, Cyril Morris, put many of Insall's recommendations into effect immediately. In 1969, a conservation area of 200 acres was declared, covering the city within the walls, the Roodee and a section of the river frontage.

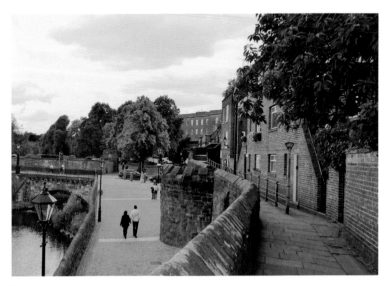

City Walls in 2010

The first image of the walls at Bridgegate is dated 1912, and the second one is dated 2010, but this doesn't really matter as very little has changed between the first scene and today. Chester still has a tourist attraction to be proud of and as a result of the report, not all modernisation within the city walls gave cause for objection – some slipped in though!

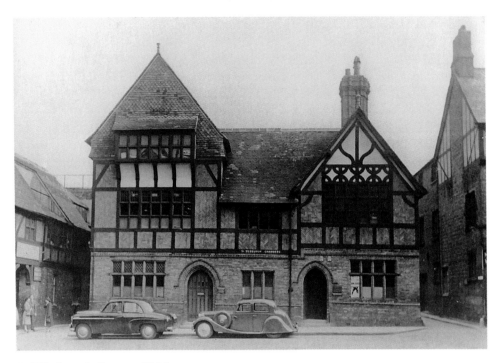

St Werburgh Street, 1964

A good example of successful redevelopment, albeit in the late 1800s, is St Werburgh Chambers in the street of that name. This was one of the sites that was in need of redevelopment in 1872 and John Douglas submitted a plan to the Council to develop it. Consent was given and the building was constructed between 1872 and 1873, at a time when a lot of Chester's black-and-white architecture was replacing worn out buildings. It was built for one of Douglas' clients, Mr G. Hodkinson, and was given the No. 29 and No. 33 St Werburgh Street. When photographed in 1964 it was two shops, numbered 29 and 31. For the excellent work that John Douglas was responsible for in Chester and elsewhere, his plaque in St Werburgh Street is well deserved. Back in the 1960s, the council began an exemplary policy of acquiring, restoring and selling buildings, and encouraged private owners, developers, and architects to undertake similar renovation work backed by council and government grants. A new conservation rate of 1*d* in the pound was implemented, at the time unique in English cities. It was expected to raise £30,000 a year for a conservation fund.

5

A House Called Nowhere

If you were to take a stroll along Sty Lane, the pleasant, almost rural path that connects Edgar's Park with the Grosvenor Bridge, you would pass by a small white cottage bearing the intriguing name of Nowhere. For many years, this house on the banks of the Dee has been the subject of speculation as to the origins of its curious name. It was said to have been built in the early nineteenth century to accommodate the Clerk of Works for the construction of the Grosvenor Bridge, but old maps show the house standing as early as 1789. Records seem to indicate that it was actually built by a fisherman named James Bingley and that its original name was simply Riverside.

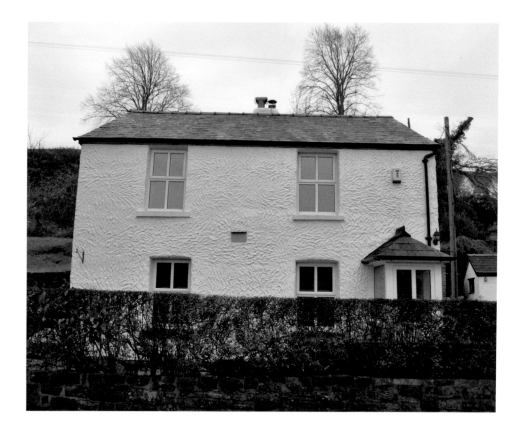

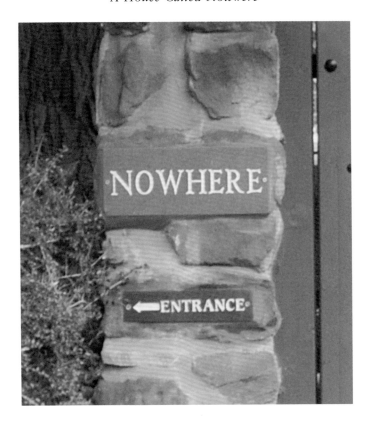

A House Called Nowhere

The house was occupied by the same family until at least 1850 and then passed to one Nan Youde, who was a relative of the Bingleys, the family who gave the house its remarkable name. It was suggested by two elderly sisters, the Misses Brown, who used to stop and chat with Nan on their daily walks to the riverside from their home in Curzon Park. Their sentiments were that the house stood 'in the middle of nowhere', and that this seemed an appropriate name for it. Nan was happy to oblige, and from that day the house became known as Nowhere. Nan's relatives, the Smith family, resided there for a further forty years, leaving around 1960. The property, which had at some point been split into two small cottages named One and Two Nowhere, were sold to a Mr Lewis, who converted them back into one large detached house.

A local fisherman's tale of the cottage was that it stood in the middle of 'a high life, a low life and a no life' – the 'high life' being Overleigh Manor, which stands on the cliff overlooking the cottage where the squire of the village once lived. The 'low life' was old Greenway Street, the home of the salmon fishermen and their families, and the 'no life' was, of course, the nearby Overleigh Cemetery.

A further legend has it that long ago, the building was an unofficial pub – a secret drinking and meeting place for the menfolk of Handbridge. When asked by their wives where they had been, they were able to answer, 'Nowhere, dear!' The house known as Nowhere also has a supposed link to the Beatles. While they were at The Royalty in 1963, they heard tales of a cottage on the banks of the River Dee near the Grosvenor Bridge, bearing the intriguing name of Nowhere. John Lennon was so fascinated he visited the house to see if it was true and later wrote a song, featured in the album *Yellow Submarine*, entitled 'Nowhere Man'. John incidentally had another Chester connection, for his maternal grandmother, Annie Jane Milward, was born at the ancient Bear and Billet Inn in Lower Bridge Street back in 1873.

More of Chester's Historical Past and What Happened in the 1960s

Chester is an ancient city with numerous historical sites due to the rebuilding and expansion of this fortress city over the years. This reconstruction continued throughout the centuries of occupation and, in its final form, Deva, later Chester, would have covered an area of about 65 acres. With its imposing walls and great buildings, it must have been a breathtaking sight. A large amphitheatre outside the southeast corner of the fortress could seat 8,000 people.

Such was the size of the fortress and grandeur of its architecture, that it was most likely Chester would become the capital city of Roman Britain. Unfortunately, the preservation of antiquities has not always been a respected priority as it is today. The amphitheatre, a massively important relic of the Roman occupation that was allowed to disappear and eventually become buried under buildings, was not to be rediscovered until the twentieth century. Even now, only half of it is on view and the remainder still sits beneath a large building.

The Amphitheatre in the 1960s (*Opposite*) and in 2014

Its attitude to the Roman amphitheatre was the greatest test of the council's commitment to uncovering Chester's ancient history. In 1949, the Ministry of Works offered to excavate it if given guardianship. The council agreed and work began in 1960. Since Dee House, sitting proudly on half of the hidden amphitheatre, remained in private hands, only the section already owned by the city and the Archaeological Society could be excavated. The work proceeded slowly throughout the 1960s, partly because of difficulty in shoring up the adjoining higher ground. This work continued very slowly into the 1970s.

The 1960s redevelopment of the city centre provided a unique opportunity to discover more of the Roman fortress. The excavations, which were funded by the government and the corporation, revealed the plan of a unique elliptical building and Roman floors on the Forum site, and the full extent of the bathhouse, together with part of a barrack block, under the Grosvenor Centre. The destruction of the remains of the baths, still of great size and a high degree of preservation, provoked much controversy. The quite unique remains of the Elliptical buildings were obliterated when the ironically named *Forum* council offices were constructed in the 1960s. During Roman times, Chester's occupants, despite hailing from every corner of the known world, were all (with the obvious exception of the slaves) counted as citizens of Rome, and therefore enjoyed rights, laws and a standard of living the likes of which would not be seen again in Europe until modern times.

Chester Police Headquarters

In 1857, Chester's first headquarters was opened at No. 4 Sellar Street in the city. This was the home of the Cheshire Constabulary. In 1862 it moved to No. 1 Egerton Street, then in 1870 to No. 113 Foregate Street. These were pre-existing buildings taken over by the force, but in 1893 a new police headquarters was built by Chester City Council at No. 142 Foregate Street on what was the site of an eleventh-century Benedictine nunnery.

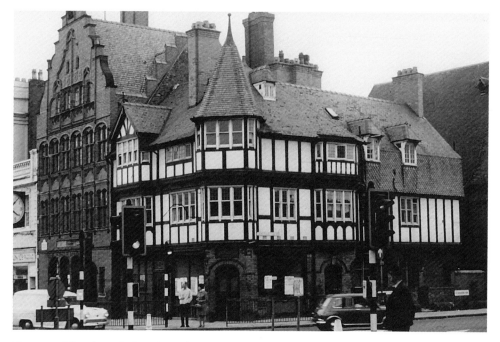

Former Cheshire Police Headquarters, 1965

This photograph is of the police headquarters at the junction with Foregate Street and Grosvenor Park Road. It is the red-brick building at the other side of the black-and-white one, the latter being demolished to make way for the inner ring road. The red-brick police headquarters building was designed by John Douglas in a style not usually attributed to him. It remained the headquarters of the Cheshire Constabulary until the next was built in 1967, and, after that, was used by the force and the council as an occupational health unit.

As for the police force, it must be remembered that this was then the county-wide Cheshire Constabulary. It included major towns that did not boast their own borough police force under the control of their own chief constable. Chester City Police were based in the police station within the town hall. These borough forces pre-dated the Cheshire Constabulary by around twenty years, and comprised the county's eight borough forces, Chester included.

The Police Act of 1946 saw five of the borough forces incorporated into the Cheshire Constabulary, of which Chester was one, and it continued to be based in the police station at the town hall. Boroughs were not included and allowed to remain autonomous were Stockport, Birkenhead and Wallasey. It was not until 1965 that they too were amalgamated into the Cheshire Force. Accordingly, the Foregate Street building was too small to house the departments and staff. The force sought a new location for the headquarters that covered the whole of Cheshire, including towns that are now in Lancashire and Greater Manchester. The foresight was, I submit, appalling. Chester was almost in Wales and the headquarters building was to cover the likes of Macclesfield, Dukinfield, Stockport and Birkenhead. So, what final decision did they come to? Not a large extendable plot of land such as the Vale Royal Abbey in mid-Cheshire, which I believe was suggested, but a high-rise building on a very small footprint on the Welsh border in Chester city!

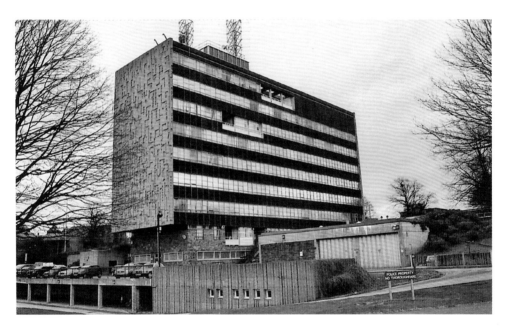

Old Police Headquarters, 1990s

Situated on a small plot of land on Nuns Road, this large, ugly and inappropriately sited building sat at the junction with Nicholas Street, which was by then a very busy inner ring road. The new county police headquarters was designed by the county architect Edgar Taberner and built between 1964 and 1967, at the astonishing cost (for the time) of over half a million pounds. The 'sculpted' ends of this otherwise drab block were designed by W. G. Mitchell, and were made by pouring concrete into polystyrene moulds. They actually won a National Civic Trust award in 1969, even though the local branch objected to the building's design.

In 1967, the year that the new police headquarters was opened, the Cheshire police were tasked with dealing with a horrific plane crash in central Stockport that killed seventy-two people. Also in that year, the Panda Car system of police patrols was introduced in Cheshire, initially using

Ford Anglias, but later using Vauxhall cars from Ellesmere Port. When commenting on the new headquarters, renowned architectural commentator Nikolaus Pevsner wrote of the building,

> Extremely objectionably sited, an eight-storey block immediately by the propylaea of the castle and turning towards it a windowless wall with an aggressive all-over concrete relief.

The Royal Fine Art Commission criticised the design around the same time. However, Donald Insall, in his influential report of 1968, cited the building as 'an example of beneficial change within the city'. He found it to be 'well related to Grosvenor Street and the castle'.

Incorporated into the lower parts of the police headquarters were sandstone blocks from the castle-like militia buildings, which formerly occupied the site. These old buildings had been demolished in 1964. They were built just after the Crimea War (1854–56) and they were, in later days, used as married quarters for the families of troops serving at the castle.

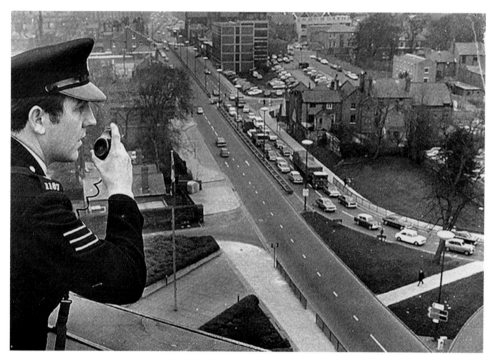

George Jones

The above photograph was taken in the late 1960s and shows Sgt George Jones, later Detective Chief Superintendent, observing the traffic on the roundabout and looking down on St Nicholas Road.

In February 1998, it was reported that the police intended to move out of their 'crumbling' thirty-year-old building, as it was 'too cramped'. It had already spread out to other buildings rented in the city. The Chester Police Division had confirmed a move to the site of the recently demolished Arts Centre in Blacon, and were looking for a location for a city centre base while their county colleagues wished to relocate elsewhere in Cheshire. The date for this move was 2003, when the headquarters of the Cheshire Constabulary moved to a purpose-built building with ample space in Winsford. Well common sense prevailed at last, and it only took thirty-six years!

What would be the fate of their present building was, at the time, anybody's guess. A report that it was to be demolished to make way for a hotel had been officially denied, which led most locals to believe that there was probably something in it. Whatever the case, few would be sorry to see it go, as they only hoped that the building that eventually replaced it would be, for a change, something the city could be proud of. Three years later, in February 2001, the building was formerly put up for sale. It was reported, 'A number of potential developers, including leading hotel chains, have made their interest known'. The city council's Design and Conservation Manager commented that 'There are two alternatives – either keep the building and refurbish it, or replace it.'

There has been a lot of debate about the present building and there are mixed feelings about it. However, it is of architectural importance; it is a gateway site for the city and is in a conservation area. In addition, the space around the building is protected and contains very significant archaeology. So it had to remain an eyesore to most and an architectural gem to others. Naturally, after all of this talk and numerous extensive meetings, the great and good decided to demolish it!

Start of Demolition

A year later, in February 2002, city council planners duly recommended that the building be demolished to make way for a 'prestigious' new development. They made it known that they would favour a three- or four-storey building that would create jobs, such as a hotel, leisure or conference centre. It had emerged that Cheshire Police would be relocating to their new purpose-built headquarters at Woodford Business Park in Winsford at the end of 2003 and the site would become available for redevelopment soon after. Even those self-appointed guardians of our city's heritage, the Chester Civic Trust, who, just a few years ago, thought it would be a good idea to build a bunch of glass-and-steel office tower blocks at the Old Port, to 'provide a 'gateway' to the city and be a commercially stimulating centrepiece for the revival of the area' decided not to campaign for the preservation of the building. They were, however, 'cautious' about the prospect of outright demolition and were said to recognise the value of a building 'so clearly of its time'. They suggested that a 'sensitive refurbishment' may have been more appropriate. In this, they were as successful as they were trying to save the militia buildings. But then their national organisation did give the thing an award, 'for its outstanding architectural contribution to the local scene' back in 1969.

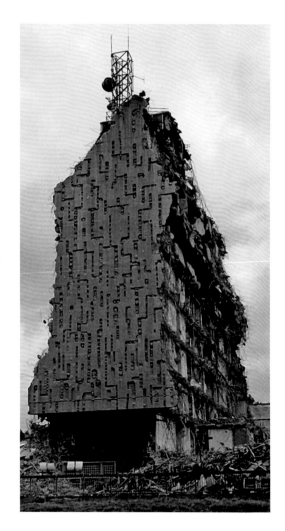

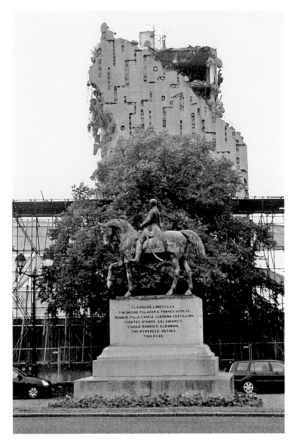

Demolition Continues

The statue of Field Marshall Viscount Combermere and his horse sit astride the plinth that has seen the ugly old building come and go. If he were alive, he may just have something to say about it. Whether he would have been happy with the replacement would be open to speculation – I rather like it though and, having stayed there, find it quite acceptable! The new building is an up-market hotel called the Abode, and is shared with Chester Council, who had handed over the council offices by the Dee to the University of Chester.

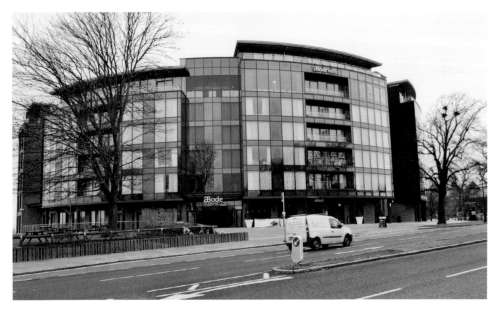

The New Hotel and Council Offices, 2014

8

Chester Zoo

Chester Zoo is one of the biggest in the country and attracts visitors from far and wide. The recent TV serial *The Zoo* told the story of the early days when the Mottershead family of Crewe wanted a zoo without bars and the trials and tribulations that the project caused them. For those not lucky enough to watch this excellent series, the brief historical details are as follows. Back at the turn of the twentieth century, a boy named George Mottershead was taken to Belle Vue Zoo in Manchester and what George saw that day inspired him to do something different. Determinedly, he told his father, 'When I have a zoo, it won't have any bars.'

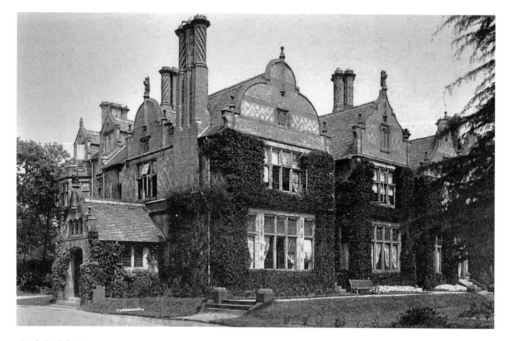

Oakfield Manor
George never forgot that day, or the vow he made; in 1930, then grown up and with a family, he bought Oakfield Manor and 7 acres of land for £3,500. And with him, he brought a group of animals from a zoo at Shavington, near Crewe. The first animals of Chester Zoo.

The zoo opened officially on the 10 June 1931, when it was staffed almost entirely by the Mottershead family. George was the director, his wife Elizabeth dealt with the catering and Muriel, their eldest daughter, was the zoo's first curator. June, their youngest daughter, was too young to do very much, but as portrayed in the television series, she was most certainly an active member of staff. It is in June's excellent autobiographical book *Our Zoo* that she describes 'The real story' of her life. George's mother and father completed the lineup of family members all with jobs to do. In 1934, the North of England Zoological Society was born, but the early days of the zoo were difficult financially and it was ten years before it was able to show a profit. Keeping the young zoo open throughout the Second World War was no mean feat, but George did it; he wasn't one to give up easily. With the war over, the zoo began to grow – fast. One of the zoo's slogans back then was, 'Always building'. George's amazing energy, enthusiasm and skill earned him an OBE.

This, however, is a book about Chester in the 1960s. At the start of the decade, in 1960, 840,000 visitors enjoyed the new Fountain Restaurant and Cafeteria, additional gardens and a pair of gorillas arrived. The small mammal house was built. The following year, the present elephant house was built and as the elephant enclosure, it was given the title of the pachyderm house. At the time it also housed rhinos, tapirs, and hippopotami, but by 1963 the zoo had completed the dedicated rhinoceros and monkey houses. By the 1960s, motorway building was surging ahead, enabling the visitors easier access to the zoo. Accordingly, in 1963, annual visitor figures topped 1 million for the first time. Boris the chimpanzee is, at the time of writing, a popular attraction at the zoo and it was in 1969 that he arrived. This means he has reached the grand old age of forty-eight.

Life at the zoo was good but not completely without problems. A big one occurred in 1968 when Britain was visited by foot and mouth disease; the zoo was not immune from the worry that this awful disease caused. Fortunately, the zoo escaped, although not completely. It was closed for eleven weeks. There was a huge press campaign supporting the zoo and, as a result, when it opened, it enjoyed the busiest Easter Monday ever when 40,000 visitors came to the zoo.

There was another feather in the cap for the hard-working and determined George Saul Mottershead when, in 1961, he was elected as president of the International Union of Directors of Zoological Gardens (IUDZG). The 1963 meeting of the UDZG Conference was held at Chester. Then, again in 1964, he received an honorary Master of Science degree from Manchester University for his services to Zoology. It was the society's thirtieth anniversary in 1964 and the tropical house (now Tropical Realm) opened on this day. The building was considered to be well ahead of its time and included a nocturnal exhibit, as well as indoor quarters for gorillas and pygmy hippopotamuses, and the present reptile area. The main part of the zoo was planted as a tropical forest. It housed a large variety of smaller free-flying birds, and those that may be a little less sociable were held in aviaries. In 1965, the collection of birds included quetzals, cock of the rocks and ten species of birds of paradise. Throughout the 1960s, construction work continued and 1965 saw the building of cafeterias and a souvenir shop. A cat house was built in 1966, and a jaguar enclosure in 1967. By 1967, visitor numbers peaked at more than 1.14 million. The zoo acquired an adjacent farm and this increased the zoo's total estate to 330 acres (133 hectares). In 1968, a small veterinary laboratory was built but never expanded because of daily visits from veterinarians at a nearby practice. The building is presently used as orangutan quarters, which were originally opened as the ape house in 1969. Now arguably the most successful zoo in the world can be found in the small Cheshire village of Upton By Chester. Its work in the protection of many animal species under threat sits comfortably with its attraction as a world-class visitor centre.

9

More Gains and Losses

We are now looking up St Werburgh Street, which most certainly avoided any damage but was there during the 1960s. This was another area for which John Douglas can be held responsible and probably the reason that the plaque recognising his achievements is on the wall there. In the 1890s, Chester City Council decided to widen St Werburgh Street, which leads from Eastgate Street to Chester Cathedral, and arranged for the demolition of a row of old shops on its east side. They intended to sell the vacant land in separate lots, but John Douglas bought the entire length of the east side of the street and planned to create a series of buildings in a unified architectural design. Douglas originally intended to construct the buildings in stone and brick in Gothic style. However, he was persuaded by the Duke of Westminster to include his famous black-and-white half-timbering in his design. The terrace was constructed around 1895–97 at a cost of over £17,000 (£1,680,000 as of 2014).

Liverpool Bank Building, Eastgate Street
The building at the south end, on the corner of Eastgate Street and St Werburgh Street (seen here on the right) was the first to be occupied. It was acquired by the Bank of Liverpool and the other units were used as shops. If you look up at the front of this beautiful building, you will see evidence of the words Bank of Liverpool. This bank was founded in 1831 and, in 1918, it acquired Martins Bank and the name changed to Bank of Liverpool and Martins Ltd. The name was shortened to Martins Bank again in 1928, then in 1969 it was acquired by Barclays Bank when all of its 700 branches became Barclays. When later photographed on a bright sunny day in 2010, it housed the Sole Trader shoe shop.

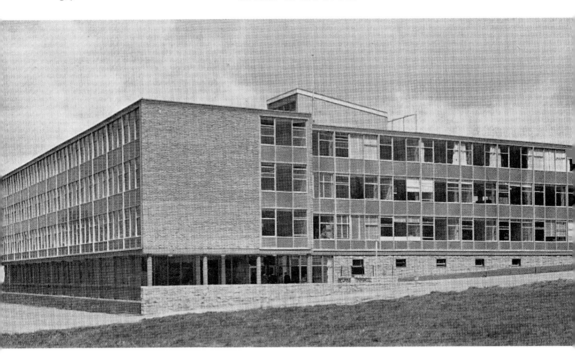

Telephone House Tower Wharf

Tower Wharf is situated on the Shropshire Union Canal, also known as the Chester Canal by the Northgate staircase locks. This is a very picturesque area of Chester, taking its name from the nearby medieval water tower. Tower Wharf is a particularly interesting corner of Chester that is well worth leaving the walls to explore. It is now redeveloped by British Waterways to a very high standard. Back in 1962 the building was known as Telephone House, shown in the photograph, and dominated the skyline. This building was the British Telecom office block; it was quite new when photographed, but was demolished in 1998 when the site was redeveloped. Its passing was mourned by very few, as it was considered a blight on what was an extremely attractive Canalside attraction. British Telecommunications PLC still works from Tower Wharf, but not from this rather ugly building.

Williams & Williams
Reliance Works

Here we have Chester's once biggest employer, Williams & Williams, who, after the last war, manufactured metal windows. This company certainly had deep roots in Chester. The company was a competitive offshoot of the family concern of Williams & Gamon Ltd that had been established in 1859 as manufacturers of stained glass, architectural ironwork and metal-framed windows. Two of the founder's sons registered themselves as Williams & Williams Limited, and, in 1915, purchased a Georgian Mansion at No. 44 Liverpool Road. This was only a short distance from their parents' firm.

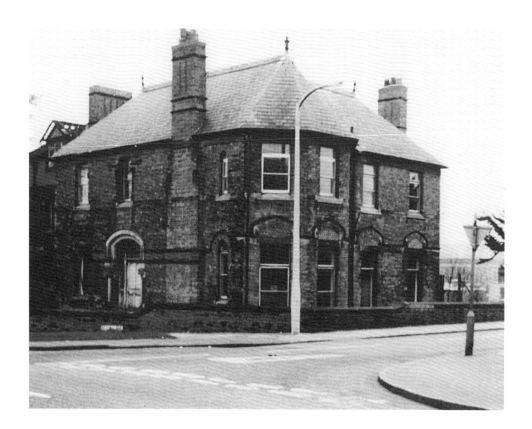

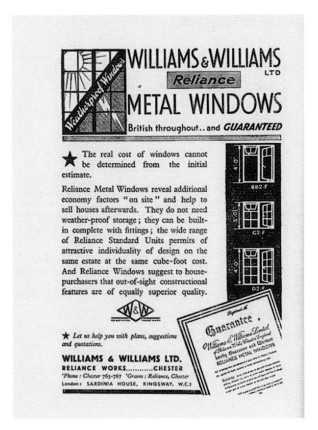

Williams & Williams, 1960

In the same year, the company was commandeered by the War Department for the large-scale manufacture of metal ammunition boxes. These boxes were to be of the company's own innovatory design. For that purpose, single-storey sheds were built at the rear of the aforementioned large house. The plant became known as Reliance Works and it was considerably extended, becoming part of the Heywood-Williams Group, who mainly used aluminium in their projects.

The company continued after the First World War, using Reliance Works and calling themselves Williams & Williams Ltd. In the Second World War, they were again engaged on war work – this time manufacturing jerry cans for water and fuel. Artist Ethel Leontine Gabain was commissioned to produce a series of lithographs and oils. One painting was titled 'Women Workers in the Canteen at Williams & Williams.' Two other paintings featured a man cutting out the jerry cans and women workers making them for the war effort. These paintings can be seen in the Chester Grosvenor Museum. After the war, they manufactured metal windows, which were popular at the time, and required both for new buildings and the pre-fabs that proliferated after the war giving temporary homes to the families made homeless.

I have been granted permission to use scans of the paintings, for which I am very grateful to Peter Boughton FSA, the Keeper of Art at the Grosvenor Museum. The one that I have used is ideal to accompany the photograph of the original building that over the years became the Reliance Works.

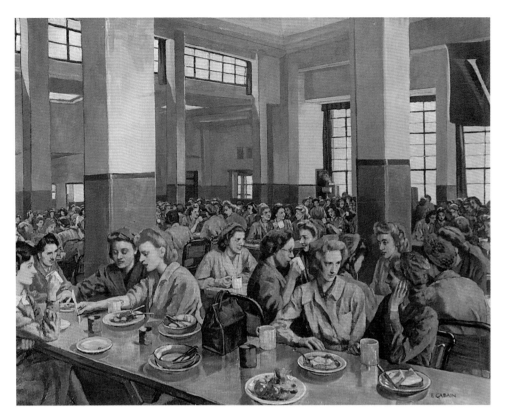

Painting of Women Workers in the Canteen at Williams & Williams

In 1961, Williams & Williams manufactured metal window frames, doors and patent glazing, employing 2,760 employees in the UK and 6,000 worldwide. They were the largest employer in Chester. In 1968, they were the builders of Rofton steel homes and were acquired by The British Steel Corporation, becoming part of the expansion of its South Wales group into building products. The house went on to provide accommodation for buyers and guests visiting the company. It and the works have now been demolished.

Chester's Old Pubs

It is time now to have a look at a few of the old public houses that went to make way for the inner ring road, and their history. But, before this, let us have a look at the famous Chester Brewery that finally closed its door in 1969. If in the 1960s you had walked down the side of the Liverpool Arms in Upper Northgate Street, now a well-known gay pub, you would have arrived at a large brewery: the Northgate Brewery, which was founded in 1760 at the Golden Falcon Inn. The Golden Falcon Inn stood close to the Northgate; it was first recorded in 1704 and for many years considered the principal coaching inn of the city, but, by 1782, it had become a doctors surgery. A new brewery complex was built on the site in the 1850s and the Chester Northgate Brewery Co Ltd was registered in March 1885 as a limited liability. The company acquired Salmon & Co, wine and spirit merchants, in Chester in 1890 and the Kelsterton Brewery Co. Ltd, Kelsterton, Clwyd in 1899, with ninety-three licensed houses.

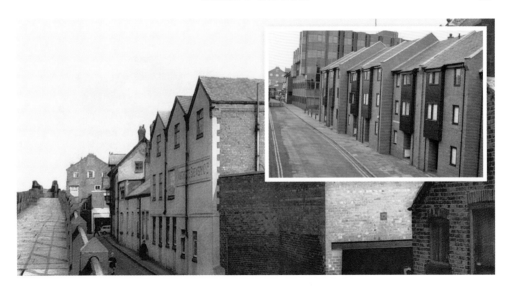

Chester Northgate Brewery and the View Today

By 1891, the company owned twenty-one tied houses in Chester and numerous others within a radius of 15 miles from the city. It was the only Chester brewery to survive beyond 1914. In its turn, it was acquired by Greenall Whitley & Co. Ltd in 1949 with around 140 tied houses. Brewing ceased in 1969 and it was demolished in 1971.

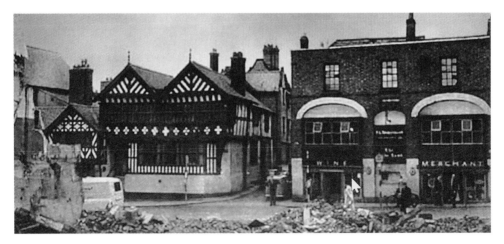

Brooksbank's & the Dive Bar – The Olde Lamb

The first of our look at long-gone pubs involves the Olde Lamb Inn. This interesting photograph shows the junction of Grosvenor Street, Pepper Street and Lower Bridge Street during the mass demolition of buildings standing in the way of the new inner ring road. People who know Chester struggle to recognise this area now. The large building with the two arched windows is the Olde Lamb Inn, which was separated from the ancient Falcon by a narrow road called Little Cuppin Street now also lost to the ring road. The Olde Lamb was known locally as the Dive Bar because you had to duck and dive to pass through the low doorway. The year is 1961, and it will soon disappear and be lost beneath the busy road junction that the inner ring road will drive straight through. Where the Lamb stands in the photograph, there remains only room for a footpath at the side of the Falcon. Also filled in at that spot is a gentleman's toilet that was accessed by a set of steps in the road. Presumably that toilet still resides there under the tarmac!

The Yacht Inn

Another well-known public house that was swept away during the building of the inner ring road in the 1960s was the Yacht Inn, described in the nineteenth century as, 'without exception the most picturesque and curious of all our Chester inns'. A century before that it was considered to be 'the premier hostelry in the city on its most important street'. Both the London and Ireland stage coaches called at its door and it was noted for its feasts, entertainments and good accommodation. However, the great churchman, satirist and author Jonathan Swift was somewhat less enthusiastic:

> My landlord is civil, but dear as the devil:
> Your pockets grow empty with nothing to tempt ye:
> The wine is so sour, t'will give you the scour:
> The beer and the ale are mingled with stale:
> The veal is such carrion, a dog would be weary on:
> All this I have felt for I live on a smelt.

Swift was a frequent visitor to Chester, passing through on his way to and from Ireland to carry out his duties as dean of Dublin Cathedral. He did not seem to greatly enjoy the experience, especially when his stay in the city was extended due to bad weather at the port. By this time, the wharves in Chester itself had become unusable and he would have had to travel a few miles by coach to the satellite port of Parkgate along the Wirral coast. During one of these enforced delays, he invited a number of dignitaries from the cathedral to join him for a meal at the Yacht, but none of them bothered to turn up. Infuriated and insulted, with his diamond ring he scratched into one of the windows: 'Rotten without and mould'ring within, this place and its clergy are all near akin.' By the mid-nineteenth century, the old inn had fallen on hard times; in 1853 it was described as 'now reduced to very humble pretensions compared to its former character,' and, a century on had become just another street corner pub.

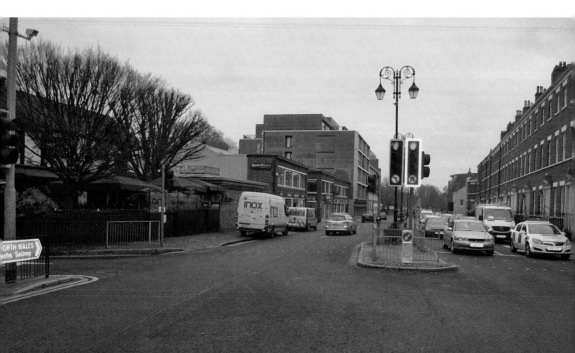

Location of the Yacht Inn today.

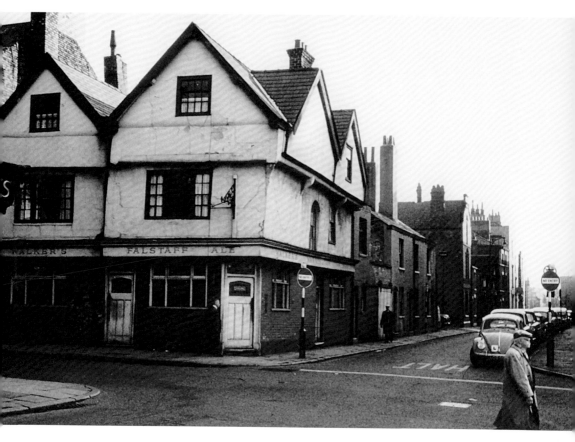

The Yacht Inn, 1963

In 1965, the ancient Yacht, its windows and ancient scratchings, together with every other building on the left-hand side of Nicholas Street, were bulldozed during the creation of the inner ring road and their foundations and cellars now lie beneath the carriageway of busy Nicholas Street. The other side of Nicholas Street escaped the demolition men, thus preserving the impressive terrace of Georgian houses that were built in 1780. The terrace was designed by Joseph Turner, and originally consisted of ten town houses. The terrace became known as Pillbox Promenade, or Pillbox Row, because many of the houses were used as doctors' surgeries. It is the 'longest and most uniform of any of the Georgian properties in Chester'. So we have to be thankful that the residents of this beautiful terrace were able to watch the destruction that was taking place across the road, but the terrace itself was kept safe. The photograph on page 60 is of the location in 2014, and the old Yacht Inn would have been where the left hand carriageway is now.

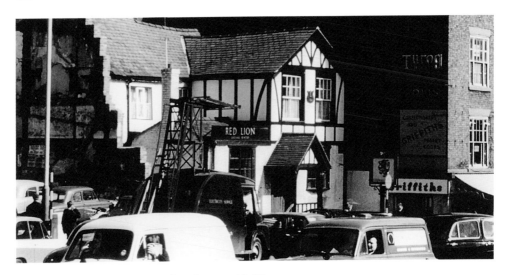

The Red Lion, Lower Bridge Street, 1965

The Red Lion Inn (later hotel) dates back to 1642, where it stood for centuries at No. 7 Lower Bridge Street. This was at the top of the street near the junction with Pepper Street, and across the road from St Michael's church, now Chester History and Heritage Centre. On the other side of the road is the even older Falcon Inn. In November 1771, one John Mainwaring, a retired butler, let it be known that he had taken 'the old and well-accustomed inn, the Red Lion'. It was, at one time, one of the numerous pubs belonging to the Chester Northgate Brewery. The Red Lion was listed in *Cowdroy's Directory* in 1789 when the licensee was William Hancock. For over 300 years, the inn occupied a setback site at the top of Lower Bridge Street until the alterations, which turned Pepper Street into Pepper Row and the inner ring road. Since then, this prominent site has been occupied by the large office block called Windsor House.

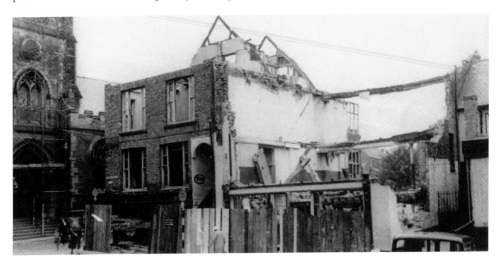

Demolition of the Red Lion

My good friend and noted Chester historian Len Morgan spoke of it as the 'notorious' Red Lion, 'the scene of many a conflict of fisticuffs, and that's putting it mildly. It was not exactly the place to take a girlfriend or go for a quiet drink'. He also added that, such was its reputation during the war that it was the only pub in Chester where US Servicemen wouldn't go. It was carpeted throughout in red 'for good reasons!' The elderly couple that ran the place up to its demise in 1968 were named Swallow.

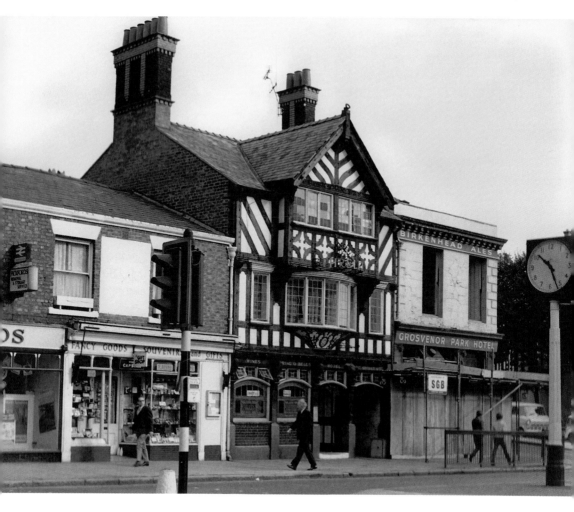

Ring O' Bells and Grosvenor Park Hotel

The Ring O' Bells and Grosvenor Park Hotel seen in the photograph were situated on the corner of City Road and Foregate Street. The photograph was taken in 1969 just before they were demolished. The Grosvenor Park Hotel went by the name of the Newpark Hotel in 1871. The licensee from 1957 to 1963 was William Wikeley. The Ring O' Bells was situated at No. 151 Foregate Street. It appeared in *Cowdroy's Directory* in 1789 when the licensee was Simon Hawkins. In common with numerous other Chester pubs, the original building had been demolished during the nineteenth century and replaced with a fancier new black-and-white one, but retaining the old name and licence.

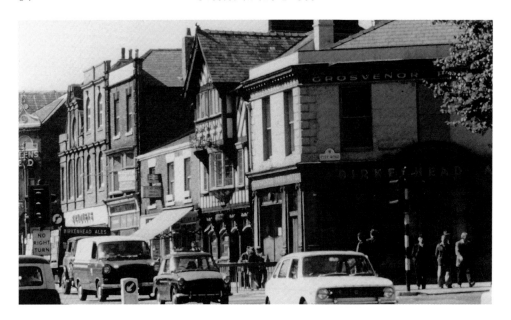

City Road and Foregate Street Junction, 1969

In this photograph with its 1968 or 1969 Austin Maxi leading the way we see both pubs were in reasonable condition considering that the demolition men were rapidly approaching. An old Chester joke was "What's the shortest distance between two pints?" The answer, of course, was "The Ring O' Bells and the Grosvenor Park Hotel!" Their site is now occupied by the Grosvenor Court offices and the City Road roundabout.

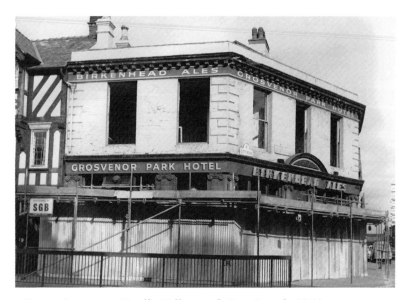

Foregate Street Junction, Earl's Villas and City Road, 1969

The Grosvenor Park Hotel was popularly known as Dick Scott's. Its landlord in 1942 was E. J. H. Scott. It is seen above in a derelict condition just before it was demolished. It can be seen in the two lower photographs as the camera photographs City Road before the roundabout swept it away.

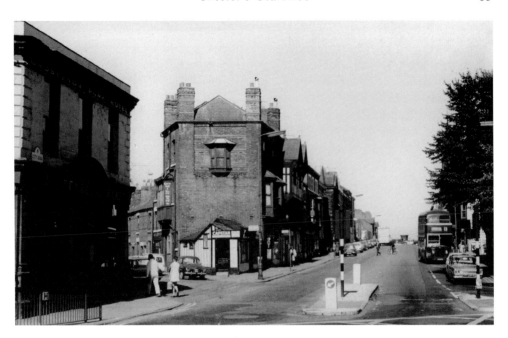

City Road from Foregate Street Leading to the Station
In this photograph we look from the side of the Grosvenor Park Hotel along City Road, towards the railway station.

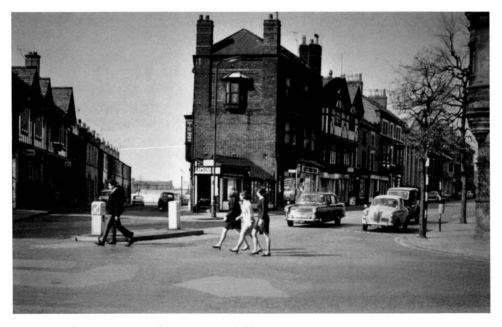

City Road, Station Road Junction, 1969
Earl's Villas, depicted in this photograph, are now all gone.

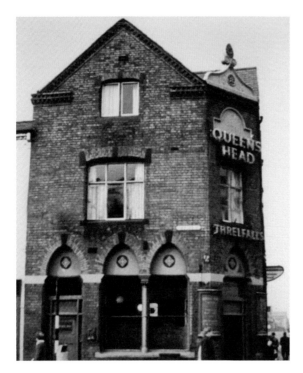

The Queen's Head

The Queen's Head hotel was on the corner of City Road and Seller Street. Together with the above mentioned Grosvenor Park Hotel and the Ring O' Bells, it was demolished to make way for the inner ring road. The site is now occupied by the Grosvenor Court offices and the City Road roundabout.

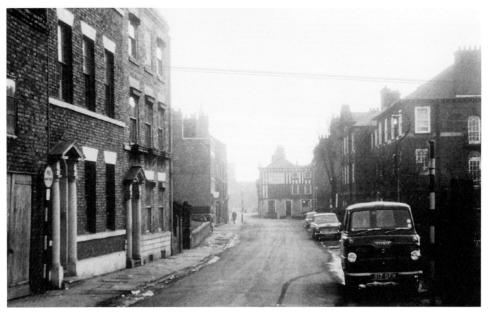

Painters Arms Pub Centre

The Painter's Arms stood at No. 1 St Martin's-in-the-Fields. Its licensee in 1818–20 was William Dobson. In 1828 (when the street is referred to as St Martin's Place), it was still a William Dobson (his relative perhaps?). In 1840, it was Mary Anne Reade, in 1857 a Mrs M. Davies and in 1880, Henry Walker. Along with everything else in the old photograph, it was demolished in the 1960s to make way for the inner ring road.

The Swan Hotel, 1960s

Now for a hotel that was not demolished to make way for the ring road, but simply to redevelop the site. In the 1960s, the Swan Hotel at No. 60 Foregate Street was one of Chester's most prestigious hotels and deserves a mention. Records identify the hotel as being there in 1540 as the Swan Inn; it later evolved into the Swan Hotel and it was one of Chester's best-known hostelries. Three hundred years later, it was said to have extensive gardens to the rear of the premises and included a fair number of cellars, tenements and shops. Prior to the dissolution of the monasteries, it had come into the ownership of nearby St John's church. Afterwards, it was purchased from the Crown by a man from Northwich called John Dean, the rector of St Bartholomew's the Great in Smithfield. He was eager to leave a lasting legacy for the children of Northwich. He was said to have helped found the Witton Grammar School and donated all of his property holding in Chester to this end. Over the next few hundred years, the trustees of the Witton Grammar School retained and leased the hotel. The grammar school still exists as Sir John Deans. The Swan Hotel continued to serve the people of Chester through the nineteenth and well into the twentieth century, although the lands were sold off. The Tatler cinema was built next door and both buildings sat side by side until 1972, when they were demolished to make way for modern shop development.

The Angel Hotel

Here is the Angel Hotel, which was situated at No. 96 Brook Street, in the triangle of Egerton Street and Francis Street. The site is now occupied by the Chester Lodge Residential Home. The property adjoining the pub has just been demolished – presumably for the widening of Francis Street, where redevelopment was taking place. It is remarkable that five pubs once faced each other at this junction, the Angel Hotel, the Glynne Arms (which is still standing but not as a pub, its namesake is in Hawarden), the George Hotel (which is still there but now used as retail premises), the Railway (also there but no longer a pub) and the Egerton Arms. Only the latter two survive here today. The Angel's landlord in 1880 was Thomas Millington, in 1898 George Gregg, in 1902 Leonard Pearson, who was still there in 1914, in 1934 Mrs Owen and in 1942 Horace Owen.

The Market Tavern, George Street

Another large and impressive pub that was demolished during Chester's reconstruction in the 1960s the Market Tavern was in George Street near to the Ship Victory (another attractive pub that is still there; however, it is rumoured that without any intervention, it won't be for long). The Market Tavern was on the corner of Thomas Street, but the front door was in George Street, opposite the Cattle Market. To the left-hand side of the pub was Thomas Street and around 50 yards to the right was Back Brook Street. The street that ran parallel to the back of the pub was Pitt Street. Having had a quick look at a few pubs that have now gone, I will balance it with one that is still up and running and successful.

Bridgewater Day Trip to Blackpool, Early 1960s

The Bridgewater Arms was listed in *Slater's Directory* of 1880 when the licensee was Mary Campbell. In 1873, it is believed to have been called The Napier. In 1910 it was listed in *Kelly's Directory* as The Bridgewater Hotel; the licensee, Mrs M. A. Bass, was still there in 1914. In 1934/35, the landlord was Edward Hargrove. The Bridgewater Arms is a pub that dates from the early 1800s. It is situated at No. 16 Crewe Street by the railway station, and as such was in a position to cater for the people working at the new Chester general station when it was built in 1848, soon becoming a popular pub for the railway workers working on the Chester railway. The pub also served as hotel to the station for a while. In the photo above, a coach is about to leave for a trip from the pub to Blackpool, the date being 1962. Cecil Lucas was the licensee at the time. How many of the people in this photograph, which is filled with period charm, can recognise themselves? This welcoming old pub has now been modernised inside and boasts the cheapest beer in Chester. How nice to see that all of the old pubs in Chester have not been swept aside in the interest of road building and modernisation.

Chester Housing in the 1960s

The early 1960s saw large areas of farmland on the outskirts of Chester being developed into residential areas, both in the form of council estates and private dwellings. A spacious layout prevailed at Newton and Upton. The Newton Hall estate was built between 1957 and 1960, Plas Newton between 1960 and 1966 and Upton Park, stretching east from Stanton Drive and Dickson's Drive to Wealstone Lane, between 1954 and 1961. To accommodate the residents of these new estates, churches, schools and other community facilities were sited on slices of open land between Newton Lane and Kingsway in Newton, as well as in the grounds of Plas Newton Hall, with shops in a commercial centre on Newton Lane. The largest of the other council developments was at Hoole, around a long road looping north from Hoole Lane to Hoole Road. Otherwise, council housing was restricted to small pockets. For example, at Melrose Avenue north of the railway and canal off Vicars Cross Road, and tucked into the Lache estate, where a small site off Willow Road was developed between the late 1960s to the early 1970s with terraces similar to those built in the later phases at Blacon. Chester was subject to only one very limited attempt at comprehensive redevelopment in the 1960s, when an area of nineteenth-century housing between City Road and Crewe Street near the railway station was replaced by a mixed development of two eleven-storey blocks of flats and four-storey walk-up blocks, with one or two nineteenth-century buildings preserved.

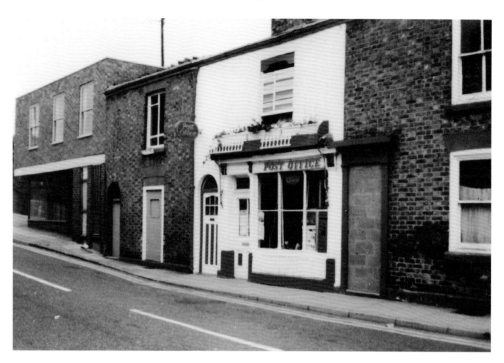

Seller Street Opposite Bold Square, 1968

Most houses on all the outer estates were plain and brick-built; they were arranged in straight terraces or semi-detached pairs. The blocks of flats, including those in the road through the Newton Hall estate, Coniston Road, were similarly plain but flat-roofed; even the multi-storey slab blocks were brick-clad, and quite low compared with tower blocks in other cities. Between 1961 and 1971, the amount of council housing increased by 6 per cent to 30 per cent of the housing stock and private accommodation for owner occupiers by 4 per cent to 52 per cent, while privately owned rented accommodation fell from 28 per cent to 18 per cent. There was more private building in Upton and Great Boughton outside the borough boundary. There was also an influx of middle-class house purchasers into Chester as a whole and this was so obvious that, in the late 1960s, estate agents reported that the city was becoming a dormitory for middle and higher income groups.

The attractiveness of Chester as a place to relocate is obvious, but this was acerbated by the white-collar companies that were arriving and bringing with them a more affluent workforce. Throughout the 1960s, cheaper private housing was built next to council estates. In 1960, at Blacon, forty-four houses in Western Avenue and Highfield Road were designed for sale by the council itself, and at Lache around 1960–62, Oldfield and Snowdon Crescents and Clifford Drive were laid out like adjacent council estate roads. One of the largest schemes was at Upton and Newton, where the east end of Plas Newton Lane and the area south of it was developed with over 100 semi-detached houses and bungalows along streets including Ullswater Crescent, Ambleside and Derwent Road. Although planned in 1955, the scheme was not completed until the mid-1960s and from 1963 was continued east into Ethelda Drive and Kennedy Close. Similar housing was scattered throughout the area north of Vicars Cross; road sites between existing housing and new or improved roads were also exploited. In Hoole, cheap semi-detached housing in Pipers Lane was built as a fringe between council housing to the west and the bypass (A41) in the east. In Lache, an estate approved in 1966/67 was built between Lache Lane and Wrexham Road, with its focus being a sizeable shopping parade on Five Ashes Road.

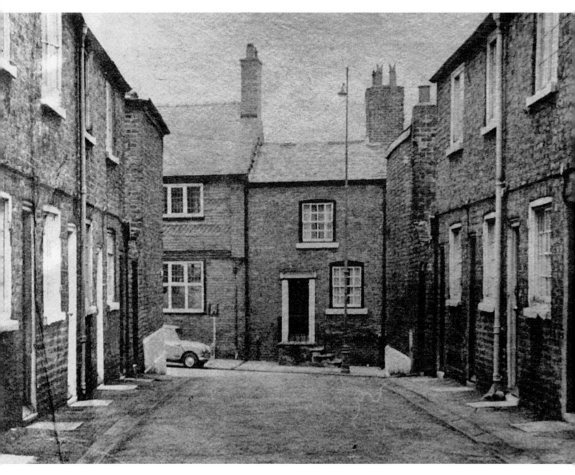

Belgrave Place, Handbridge, 1960s

As previously mentioned, as a result of the larger population there was a need to demolish and rebuild properties that were coming to the end of their lives, without of course upgrading them to the present-day standards. In 1969, the City Conservation Area was designated. The main emphasis of this area was to save historic buildings instead of building new. Examples of buildings being saved through the City Conservation Area are the Falcon Inn, Dutch Houses and Kings Buildings. The photograph above of Belgrave Place, Handbridge, was not so lucky. Only the houses at the end with the Mini outside one of them now remain.

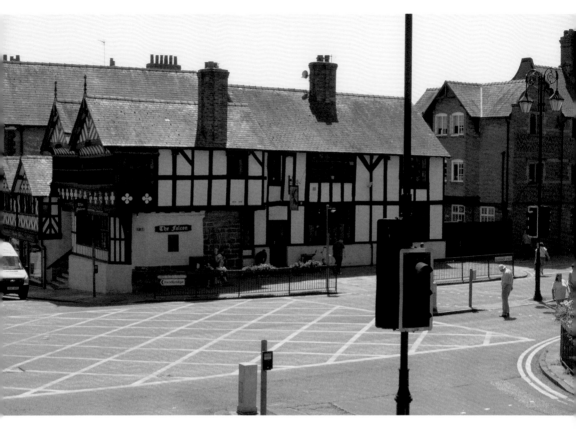

The Falcon

Time for a little look at the Falcon, although briefly as I also covered it in *Chester in the 1950s*. This shows a modern photograph of the ancient and interesting pub. It gives a later insight into this area. The Falcon can be clearly seen and on this side of it, prior to demolition, was the Lambe Inn, as can be seen in other photographs in the book. It dates back to around 1200 when it was built as a private house and was later extended along Bridge Street. When it was rebuilt in the thirteenth century, a row or walkway was added through the front of the property. This lasted until 1642. In 1602, Sir Richard Grosvenor had purchased it, and forty years later he extensively altered it to make it his family's town house. He also petitioned for permission to enclose the row, making it part of the building. This led to other Bridge Street owners doing likewise, hence there are not as many of Chester's rows in this area of Lower Bridge Street. It was first used as an inn in 1778, then around a century later it was restored by the famous architect John Douglas. At this time the Temperance Movement was popular in certain quarters and the Falcon became the Falcon Cocoa House, serving only non-alcoholic drinks. Through the 1960s, the pub lay empty and derelict, but it was later restored by The Falcon Trust and reopened as one of Chester's ancient and popular watering holes.

A 1960s Walk Down Eastgate Street and into Frodsham Street

Taking an anecdotal look at Chester now and walking the streets of the 1960s city, what do we find? It was in 1961 that traffic wardens were introduced to the Chester/Cheshire area to the joy of Chester's drivers, who embraced them with open arms – alright, I was joking then. On a happier note, it was in 1967 that another innovation was introduced when the Road Safety Act introduced the breathalyzer. No more would people be allowed to merrily drink their fill and make their way home erratically in something that boasted an internal combustion engine – not without the high possibility of being caught doing so anyway. Many an errant driver has stood at the roadside since praying that the crystals in the little glass tube would not turn green. That was before technology arrived and the little glass tube with its polythene balloon gave way to a fancy machine. The 1960s saw the building of the Grosvenor Centre near to the hotel of the same name, adding to Chester's already impressive selection of shops at both ground level and in the quite unique rows.

Bridge Street Row in 1962 (*Opposite*)

The popularity of Chester as both a place to live and a tourist destination cannot be underestimated; the city has so much to offer. The importance of tourism to the city's prosperity was a little more appreciated in the 1960s, although it wasn't until the next decade that work really did start on preserving this most beautiful of cities. Tourists included daytrippers, overnight visitors on their way to resorts in North Wales and foreigners, for whom Chester was near the top in several lists of the most desirable tourist destinations. The number of hotel bedrooms grew from 700 in 1960 to 1,300 twenty years later. Visitors were drawn in by the antiquity of the city and by the shops, many of which are situated in the ancient Rows, whose character after 1947 was preserved by planning legislation.

Chester is the only walled city in Britain in which the walls are complete, and the walk around the full circuit cannot be beaten. Around 2 miles in length, this easy and mainly flat circular walk has lots of appeal and lots to see both by the regular walker and the visitor. However, let us look at a few of Chester's town centre streets, starting with Eastgate Street and the famous Eastgate clock. First, one sets off from Chester's famous meeting place, the area from which the town crier has for many years addressed all present – the cross. It is situated at the junction of Eastgate Street, Watergate Street and Bridge Street in the city centre (which in 1960 did not have a cross there). Like the famous Sandbach crosses, the Chester cross, which was at this location through the centuries, was destroyed in the name of iconoclasm in the English Civil War when religious artifacts were summarily smashed and carried off. It was not until the 1970s that a lot of the pieces were brought back and re-erected here in their rightful place. Chester's famous cross was returned to its deserved place.

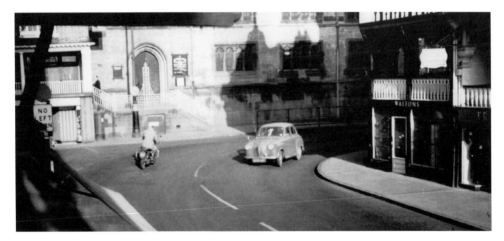

Looking Up Bridge Street in 1962

Here we see an Austin A35 slewing from Eastgate Street into Bridge Street, but notice that there is no cross in the left-hand corner. As we pass the location of the cross we walk beside the impressive and ancient church of St Peter and then past the junction with Northgate Street. We are now in the centre of the city's shopping area and each side there are shops, bars and restaurants on two levels, as there had been for centuries years before. The next junction we arrive at is St Werburgh Street, which leads to Chester Cathedral. Across the road is the Grosvenor shopping centre, built during the 1960s. In my humble opinion, it is quite impressive and subtly blended into the surrounding area. It is also what you could liken to a tardis from *Dr Who*. Pass through the entry portal, and a very big shopping centre is spread out before you. Next to this is Chester's top hotel, the Grosvenor, a name that you will come across in many parts of Chester thanks to the family name of His Grace Gerald Grosvenor 6th Duke of Westminster, who lives in Chester at Eaton Hall. Pass the Grosvenor and through Eastgate. Then we pass Frodsham Street and St John Street. Let us dip into Frodsham Street and look at one of the companies that reside there.

Frodsham Car Dealers: Hooton Engineering

Typical car sales of the 1960s are well worth a look at. Here are some of the cars of the period. Left to right: a Riley Elf, A Mk1 Austin 1100, a Mini and two Ford Cortinas. Towards the end of Frodsham Street we find a typical area of 1960s buildings, buildings of the style that were erected all over the country during this period. They were perhaps not the most desirable years for building, proven by the fact that some have already gone. Here though, we have the Army and Navy stores, a pub and a restaurant in typical 1960s contemporary style.

Frodsham Street, 1960s

If we continue to the end of Frodsham Street we will find Cow Lane Bridge and onwards to the new City Road roundabout and the area still known as The Bars. As we walk back along Frodsham Street we find a lot to tempt the shopper; a supermarket has been built and, like the Grosvenor centre, it is set back and does not detract too much from the older buildings around it. Having looked in some detail at Chester's iconic Browns of Chester store, now part of the Debenhams group as seen in *Chester in the 1950s*, it's time to check out another one of the major retailers in Foregate Street, Marks & Spencer.

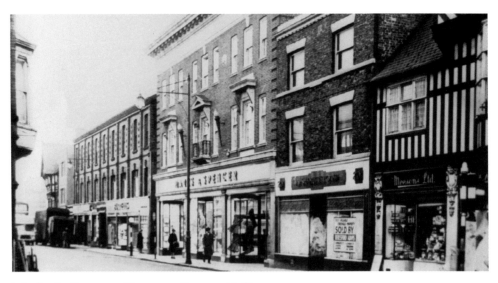

Marks & Spencer, Foregate Street, 1962

Let's have a quick review of Marks & Spencer leading up to the 1960s. The company was founded by a partnership between Michael Marks, a Belarusian Jew from Slonim. He was born into a Polish-Jewish family, consisting of a Polish refugee living in the Russian Empire and a cashier from the market town of Skipton in North Yorkshire. When he arrived in England, Marks worked for a company in Leeds called Barran, which employed refugees. In 1884, he met Isaac Jowitt Dewhirst while looking for work. Dewhirst lent Marks £5, which he used to establish his Penny Bazaar on Kirkgate Market in Leeds. Dewhirst also taught him a little English. Isaac Dewhirst's cashier was Tom Spencer, an excellent bookkeeper, whose lively and intelligent second wife helped improve Marks' English. In 1894, when Marks acquired a permanent stall in Leeds' covered market, he invited Spencer to become his partner. In 1901, Marks moved to the Birkenhead open market where he amalgamated with Spencer. In 1903, the pair were allocated stall numbers eleven and twelve in the centre aisle, and there they opened the famous Penny Bazaar. The company left Birkenhead Market on 24 February 1923; the next few years saw Michael Marks and Tom Spencer open market stalls in many locations around the North West of England, and move the original Leeds Penny Bazaar to No. 20 Cheetham Hill Road, Manchester.

Marks & Spencer, known colloquially as 'Marks and Sparks' or 'M&S', made its reputation in the early twentieth century with a policy of only selling British-made goods. It only started to revert from this policy in the 1990s. It entered into long term relationships with British manufacturers and sold clothes and food under the St Michael brand, introduced in 1928. The brand was named after Michael Marks. It also accepted the return of unwanted items, giving a full cash refund if the receipt was shown, no matter how long ago the product was purchased, which was unusual for the time. By 1950, virtually all of their goods were sold under the St Michael label. M&S lingerie, women's clothes and girls' school uniforms were branded under the St Margaret label until the whole range of general merchandise became St Michael. Simon Marks, son of Michael Marks, died in 1964 after fifty-six years of service. Israel Sieff, the son-in-law of Michael Marks, took over as chairman and then in 1968, John Salisse became the Company Director.

The first M&S shop in central Asia was built in Kabul, Afghanistan, in the 1960s, but was later shut down due to political unrest involving Soviet Russia. M&S now has 800 stores throughout the UK and the second largest after Oxford Street is the M&S store at the Cheshire Oaks Retail Park in Ellesmere Port. Staying in Cheshire, the third largest store is on the Gemini Retail Park in Warrington. They also have 300 stores outside the UK. Marks & Spencer also has a banking arm, the headquarters of which is in, you've guessed it, Chester!

The Dee and February 1963 – the Big Freeze

The river was also popular and motorboats were available for hire from the Groves after 1945. By 1970, annual licences were being issued for over 650 vessels. This included privately owned ones, more than three times as many as in 1950, and three quarters of boat owners lived outside Chester. The Cheshire Constabulary also had a river police with their own patrol boat called Charon. Although the importance of tourism was finally dawning on the city council in 1964, the city's attitude to tourism could still be condemned as 'passive and uncertain!'

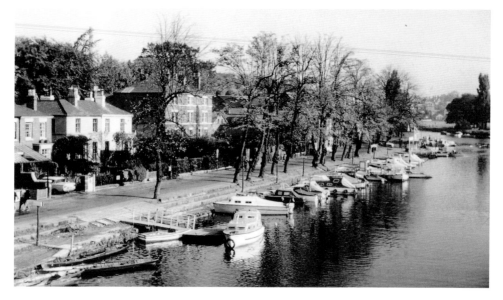

The River Dee, 1962

The council still did not boast a publicity officer or tourist information bureau, and had done little to develop potential attractions such as the river frontage. This changed over the following years, and before ten years had elapsed, efforts would be stepped up to enhance the city's natural assets and advertise them to prospective visitors.

The River Dee Freezes, 1963

1947 had a record-breaking period of frost, snow and ice, but the year of 1963 saw one of the biggest and longest freezes in history. In February 1963, the freeze was at its coldest with more snow forecast in the next few days across the UK. Needless to say, the country ground to a halt with the usual complaints of no grit on the road, rivers and canals frozen solid and people slipping over on the ice. In this photograph we see the River Dee frozen and people enjoying a stroll where they would normally take boat trips. The swans were taking advantage of the bit of unfrozen water around the weir.

The snow started on Boxing Day and there was not another frost-free day in the entire country until 5 March. There was also talk about someone driving a Mini on the river. Few had central heating or double glazing, and there was ice on the inside of the windows. The Esso Blue dealer still got through so that we could fill up our paraffin heaters to warm up the bathroom and we had to make sure there was enough coal for the living room fire. For those living out of town, it was highly likely that the electricity supplies would be affected leaving them to cook on the fire. Simply walking out had its dangers, as the snow compacted on the pavements for weeks on end. Unlike now, the schools rarely closed, but milk left on the doorstep would freeze causing the foil tops to lift off.

River Dee, 1963

Taking a final look at the River Dee during the freezing winter of 1963, we see a couple enjoying the ice and having some fun under the Queens Park Suspension Bridge. This is one of only two footbridges to cross the river; the other is at the bottom of Ferry Lane, Sealand. The bridge was originally built in 1852. When Chester Corporation accepted responsibility for this bridge in the early 1920s, they decided to demolish it. This took place in August 1922 and a new bridge, built to the designs of Mr Charles Greenwood, City Engineer and Surveyor, took its place and remains the bridge that this couple frolic beneath on the ice.

15

Chester's Entertainment During the 1960s

Cities have to be a centre for all forms of entertainment and Chester did not let the punters down. In the 1950s book we looked at Clemence's Restaurant and dance venue, and initially we will stay in the same street – namely Northgate Street, although it no longer boasts Clemence's. In the 1960s, the place to be to enjoy all of the benefits, or otherwise, of the Swinging Sixties in Chester was Quaintways nightclub in Northgate Street.

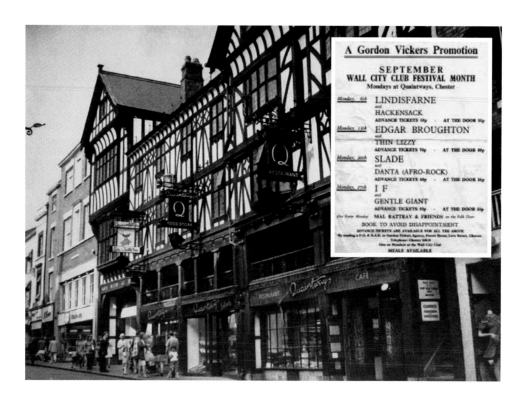

Quaintways

Quaintways was a nightclub and music venue located on Northgate Street. It was owned and operated by entrepreneur Gordon Vickers. During its heyday of the 1960s and 1970s, it hosted bands such as Fleetwood Mac, Thin Lizzy, Status Quo, Jethro Tull, Uriah Heep, Judas Priest and later the Who, Bad Company, etc. With Liverpool and Manchester nearby, one would think that poor Chester would be a second-class venue. It wasn't, in fact it was probably one of the most under-rated venues of the music-heavy 1960s. The band that we mentioned in the 1950s book, The Wall City Jazz Men, took up residence here when Clemence's closed and until Quaintways closed, only to open again as a nightclub. An attractive young hairdresser at Quaintways, who went by the name of Pauline 'Tilly' Tilston, met a Cunard waiter who was working as a chef at Quaintways. Pauline was a working class Chester girl and was something of a glamour queen with a passing resemblance to Elizabeth Taylor. At the time, Quaintways also featured a busy food hall, a ballroom and restaurant. Pauline married her waiter, John Prescott, on 11 November 1961 at Upton parish church and they settled down to married life in a semi-detached house in Pine Gardens, Upton. John was a member of the National Union of Seamen and went on to be a full-time union official, an MP, Deputy Prime Minister and Lord. So 'Tilly' Tilston, the attractive hairdresser from Quaintways, went on to be Lady Prescott living in a castle-like house in Hull.

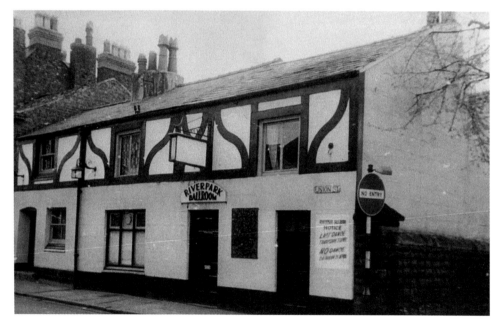

Riverpark, Union Street

Quaintways was not the only music venue in 1960s Chester. Already mentioned in the 1950s book is the Riverpark Ballroom in Union Street. It was, however, the 1960s when it came into its own. The building, at No. 2 Union Street, Chester, was originally the King's Arms Tavern. In the early twentieth century it was enlarged and became the Grosvenor skating rink, then the Broadway Dancing Academy Ballroom, known as The Ack. In the 1950s, it was renamed the Riverpark Ballroom, but closed in 1963 and was later demolished. It is now the site of a bank's office. 1962 saw a new band join the music scene, a band that had in fact been refused a gig at Quaintways because they were too scruffy. The Riverpark, however, gave them a slot. They played there on four Thursdays in the summer of 1962 and they were to gain a modicum of fame as the Beatles.

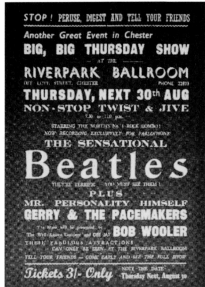

STOP! PERUSE, DIGEST AND TELL YOUR FRIENDS

Another Great Event in Chester
BIG, BIG THURSDAY SHOW
——— AT THE ———
RIVERPARK BALLROOM
OFF LOVE STREET, CHESTER PHONE 22813
THURSDAY, NEXT 30th AUG
NON · STOP TWIST & JIVE
7.30 to 11.0 p.m.
STARRING THE NORTH'S No 1 ROCK GROUP!
NOW RECORDING EXCLUSIVELY FOR PARLOPHONE
THE SENSATIONAL
Beatles
THEY'RE TERRIFIC — YOU MUST SEE THEM!
PLUS
MR. PERSONALITY HIMSELF
GERRY & THE PACEMAKERS
The Show will be presented by
The Well-known Compére and DJY at BOB WOOLER
THESE FABULOUS ATTRACTIONS
CAN ONLY BE SEEN AT THE RIVERPARK BALLROOM
TELL YOUR FRIENDS — COME EARLY AND SEE THE FULL SHOW
Tickets 3/- Only NOTE THE DATE! Thursday Next, August 30

The Early Beatles

The gig was not as straightforward as it should have been, however. Earlier that day, Pete Best had been sacked from the group by manager Brian Epstein. Best had agreed to honour the booking but later changed his mind and didn't bother turning up. He had been with the group since 12 August 1960, and he was never given a reason for his dismissal. The Beatles drafted in The Big Three's drummer Johnny 'Hutch' Hutchinson as a temporary replacement, for this show and the following evening's performances at the Majestic Ballroom in Birkenhead and the Tower Ballroom in New Brighton, Wallasey. The Big Three were also an Epstein band – in fact, Johnny Hutchinson had been offered the position as the Beatles' drummer, but he refused, insisting that The Big Three was the band he wanted to be part of. Ringo Starr joined the Beatles from Rory Storm & the Hurricanes, and his first official show with the Beatles was at Hulme Hall in Birkenhead on 18 August 1962. The Beatles in their new and permanent line up played at the Riverpark Ballroom on 23 August (the day that John Lennon married Cynthia), then on 30 August and 13 September 1962.

The Royalty Theatre

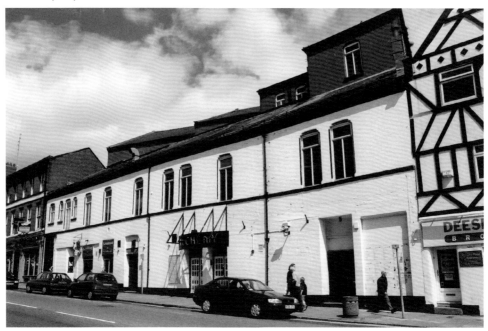

Before Demolition

The Chester Royalty Theatre in City Road first opened its doors in 1882; we looked at it briefly in *Chester in the 1950s*. Such a venerable venue deserves bringing up to date in view of the fact that it eventually closed its doors during our featured decade. So, a quick look back to that day in 1882. The opening night audience was treated to the following prologue, recited by John Bannister and written by one John Boddington, who was a member of staff at the *Chester Chronicle*. The prologue was included in an article, 'Opening of the New Royalty Theatre' published by the *Chronicle* on 30 December 1882.

> Halloa ! What's this? Why, here's an alteration.
> Is this the theatre by the General Station
> Where Sheridan so bravely fought of old
> To shield the Drama from the winter's cold?
> 'Tis not a dream result of indigestion-
> Or Fairy palace that's quite out of question.
> No! No! This chaste interior is real,
> Of genius and art the home ideal.
> The architect and artist have been here,
> And each wrought wonders in his several sphere.
> And now you'll want to know who 'twas that made 'em'.
> Do all I've said; and who it was that paid 'em.
> Of course I might inform you 'twas a sprite!'
> But then you tell me 'Walker!' You're quite right.
> 'Twas Walker Carter & Chalton hand in hand;
> They're joint proprietors you understand;
> They found a way, by dint of right good will,
> And didn't wait for an improvement bill.
> Dull, humdrum, sluggish, 'melancholy, slow,'
> Describes in numbers of the proper flow
> The sad condition of our ancient Chester

Minus the theatre. And so just to test her
And see if she'll support the regular Drama
We'll presently unfold a panorama
Of human life in every rank and state,
To fire the fancy, and to elevate
The people's notions to make rational
And gen'rous their views and still we'll fashion all
Our entertainment on this solid fact
That man's a Laughing being – and the act
Shows he's a sense of humour, which at least is
A proof that he's superior to the beasties.
'Tis certain too, as five and five are ten,
That mirth is the best medicine of men.
Throw physic to the dogs, and come to us,
And whilst, dear public, we must all confess
Tis not in mortals to command success.'
We'll strive to gain it your applause we court
And hope you'll give the Royalty support.

During the 1950s and 60s, many variety stars such as Ken Dodd, Jimmy Young, Harry Worth, Frankie Vaughan and Helen Shapiro (aged fourteen) performed at the Royalty, to be followed by pop singers and groups including Tony Christie, Alma Cogan, 'the girl with a giggle in her voice', Herman's Hermits, the Rolling Stones (18 April 1964), Gerry and the Pacemakers and the Beatles, who appeared here together 15 May 1963. The Beatles only played at the Royalty once, but made more regular Chester appearances at the Riverpark Ballroom as previously mentioned.

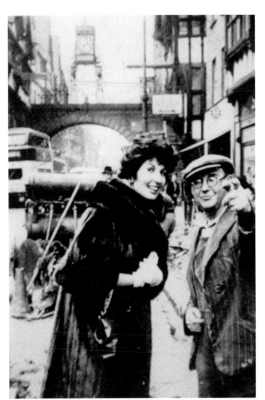

Alma Cogan in Eastgate Street

At the Royalty Theatre and mentioned above is the singer Alma Cogan. Alma performed at the Royalty in March 1960 and was a well-known singer in the 1950s and 60s. Her life, however, was cut short by stomach cancer when she died in 1966 at just thirty-four years of age. Here is a photograph of her apparently asking the way in Eastgate Street when she appeared at the Royalty.

Eventually, the ground floor of the Royalty became a 'chicken in a basket' cabaret club known as The Theatre Royalty Club. Then, changing hands several times, it was used successively for bingo, wrestling and as an indoor skateboard park, before becoming a disco known as the Warren Club, which opened on 30 August 1965. Its final use was as the home of the popular Alchemy nightclub.

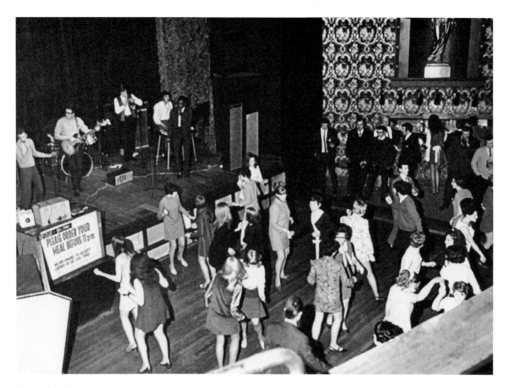

Royalty in the 1960s

Through all the changes, the decor and fittings in the upper sections of the old Victorian theatre had been removed. The resplendent gold and scarlet finery of the interior was torn out during successive refits, including some fine oil paintings of Chester's bridges, which once graced the auditorium's rear wall. Due to declining audience numbers, allegedly due to the rising popularity of cinema and then of television, the old theatre was forced to close in 1966 after a continuous run of eighty-four years. The problem was that the *Royalty* had always operated without subsidy. Ironically, the last pantomime to show there was 'Aladdin', which had been its first back in 1882. It starred the then-famous duo of Miki and Griff. In 1986, Chester City Council's Conservation Review Study recommended the development of the run-down Royalty site, 'preferably retaining the theatre auditorium'. However, fifteen years on in May 2001, it was announced that councillors had given the go ahead for the building to be entirely demolished and replaced with two restaurants, twenty-four luxury apartments and a car park. The plans for this new development in the city centre conservation area were described by the Chester Civic Trust as 'ill-mannered and profoundly unimaginative ... it is too tall, too bland and altogether unworthy'.

The Chester Music Hall

This ancient building at the junction with Northgate and St Werburgh Street was once home to the Music Hall Cinema. It is now the home of a Superdrug store.

Abbot Simon of the abbey of St Werburgh constructed the original building in 1280 as a chapel dedicated to St Nicholas. With the rebuilding of the abbey's nave in the fourteenth century, the townspeople, who were long accustomed to using the south aisle of the Abbey as their parish church and services being held at an altar dedicated to St Oswald, were required by the monks to move across the road to the former guild chapel. This new accommodation seems to have been unpopular with the parishioners from the start, as they later returned to worship in the south transept of the abbey, which was actually walled off from the rest of the great building and remained so until the late nineteenth century.

After remaining empty for a time, the old chapel was later used as a wool hall. It had also served as the Common Hall between 1545 and 1698. From 1773, it was called The New Theatre, until it was renamed The Theatre Royal in 1777, where appeared such superstars of their day as Sarah Siddons in 1786 and Edmund Kean in 1815. Both an act of parliament and the personal assent of the Monarch were necessary at this time in order to obtain a license to open a public theatre and copies of that pertaining to Chester still exist, dating from the early part of the reign of George III in 1761. Licensing was deemed necessary because eighteenth-century theatres were seen by the authorities as hives of public disorder and potential unrest. Frequenting them were drunks, vagabonds, ladies of the night – the worst elements of society. Audiences didn't sit quietly to enjoy a nice play as they do today, but would argue and fight among themselves and throw objects and abuse at the performers if their efforts failed to please. Of the Act relating to Chester, it is interesting to note that it was allied to an Act of Queen Anne for 'reducing the laws relating to Rogues, Vagabonds, Sturdy Beggars and Vagrants'.

Music Hall Cinema
Long after this, the theatre remained a source of official suspicion and plays were required to be licensed by the Lord Chancellor right up to the 1960s. In 1855, the building became the home of the Chester Music Hall, after being redesigned by architect James Harrison (who, amid much else, was also responsible for the rebuilding of Holy Trinity church in Watergate Street and restoring St Olave's church in Lower Bridge Street.

Charles Dickens gave a talk here in 1867 and later described it thus: 'The hall is like a Methodist Chapel in low spirits, and with a cold in its head'. Many other famous names gave lectures, including the explorer Roald Amundsen and Winston Churchill, who spoke on the Boer War in 1901. Films were shown occasionally from the early part of the twentieth century. The London Animated Picture Co. ran films here in 1908. Films were screened on a regular basis from 1915 when it was known as Music Hall Pictures. Chester Music Hall (1921) Ltd reconstructed the hall and ran the cinema from 1921.The screen was moved from the St Werburgh Street end to the Northgate end. The first film shown was Charlie Chaplin's *The Kid*, opening in November 1921. Chester's first 'talkie', *The Singing Fool*, starring Al Jolson, was shown at the Music Hall on 23 September 1929.

In April 1961, the Music Hall closed. The final offering was *Never on Sunday*. Since closure the building has been many things, including a branch of Lipton's, Chester's first supermarket within the walls, Foster's gents outfitters in 1978 and The Reject Shop. It is currently home to a branch of Superdrug.

The Gaumont Palace
Another cinema that ended its days in the 1960s was The Gaumont Palace. Chester's first 'super cinema', the Gaumont Palace, Brook Street, opened on 2 March 1931. The hall, designed by William T. Benslyn and run by Provincial Cinematograph Theatres, a part of Gaumont British (which later merged with Rank), housed 1,997 seats, but rounded up to 2,000 in their advertising.

Gaumont Palace Cinema
A grand Compton organ was installed that used to rise up from the stage to provide music during the interval. It was played in the opening week by Leslie James. He was famous, having made many broadcasts and recordings. Rowland H. Cutler became the full-time organist. Later, Sydney Gustard played and made broadcasts from the cinema. The first manager was Mr F. D. Rowley; he had been transferred from the Glynn in Foregate Street. The frontage of the building was mock Tudor, inkeeping with the character of the city. The first photograph shows how it looked in 1937. The entrance hall was likened to an Italian palace – the ceiling coloured blue and gold, relieved in red. The fan-shaped auditorium's ceiling was coloured orange, relieved by green, mauve and red. Illumination was by a double tier lighting feature. The upper line of light was circular and the lower hexagonal. In the centre was a diamond-shaped decorative grille pierced for air extraction. It was stated at the time of opening that the balcony seating 800 was probably the largest in Northern England. The Gaumont was the only Chester cinema to house a restaurant, and a grand one at that. The sumptuous Tudor-style Oak Restaurant remained open all day for patrons and non-patrons to dine in.

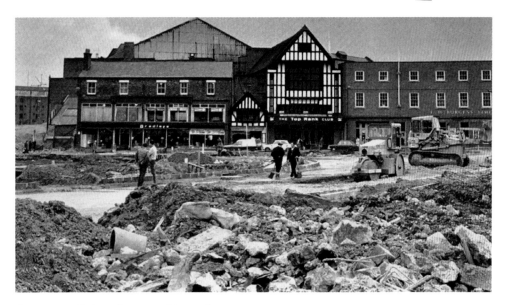

Gaumont Palace Prior to Demolition

The cinema finally closed on 9 December 1961 with the film *The Marriage Go Round*. It is alleged that Rank had actually intended to close the Odeon, not the Gaumont. The builders had moved in, destroying ornate plasterwork. It is said that Rank realised their mistake and ordered the builders to stop, but it was too late, as extensive damage had already been done. As can be seen in the last photograph of the Gaumont, after it had become a Top Rank Club, the area around it is being demolished. It soon succumbed to the demolition and men's hammers; another piece of Chester's history was crushed.

The Tatler/Classic

Chester's only news theatre, The Tatler, later to become The Classic, opened for business on Wednesday 2 December 1936. The cinema, which stood on the south side of Foregate Street showed 60–90 minutes of cartoons, comedy, travel, sport and news.

J. W. Barrow designed the Art Deco Tatler for Warrington architects William Segar Owen, the building costing around £20,000. The foyer was large, and on show was a globe with the countries outlined in neon. Also on display were four Roman Samian ware vessels discovered during the sinking of the foundations. A winding staircase led to the balcony lounge, which was small and housed two couches. The auditorium was long but not very wide. Footlights and vertical battens at the side of the stage originally provided screen lighting.

Later, after a refit under Classic management, lighting was beamed from the balcony. Auditorium lighting was housed in coves, and the curved ceiling had a sky blue lighting effect. There were wide gangways at the Tatler, and the 530 seats had armchair comfort. The cinema presented its own newsreel of local events on 16mm film called *Chester Today,* it had its own laboratory for this. Later, a spotlight replaced the 16mm equipment. This was mainly used to illuminate the ice cream sales person. In late 1937 the theatre began to show feature films. The Tatler sign came down in 1957 when Classic cinemas took control. The Classic presented films that were several years old, giving cinemagoers a chance to see films they had missed, or to see again ones long forgotten. In its last few years the movie house showed more up-to-date second runs, and films from distributors the major circuits wouldn't touch. The Tatler's slogan was 'All Chester is now going to the Tatler Theatre'.

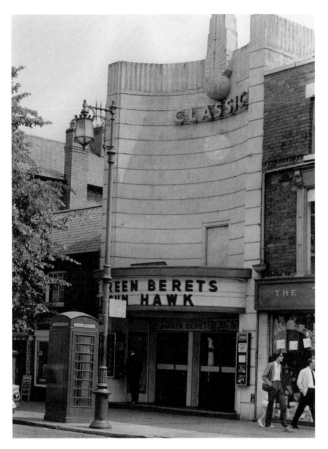

Classic Cinema with Swan Hotel Next Door

The Classic closed its curtains for the last time on 18 December 1970. The last seven-day picture was *M.A.S.H*, starring Donald Sutherland. The final late night feature was *Accident in Blue Jeans*. The Classic and the Swan Hotel, known as 'Eddie Davies', 'the hotel with the famous film performing parrots', which was next door were soon afterwards demolished to make way for a giant C&A store, which opened in 1972, later became Woolworth's and is now a branch of Primark.

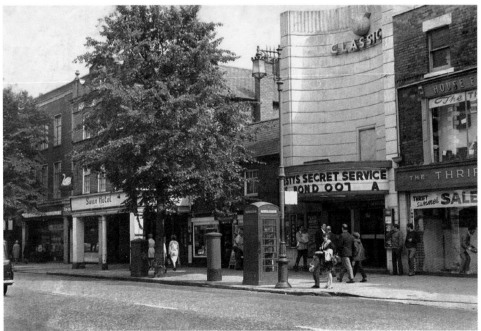

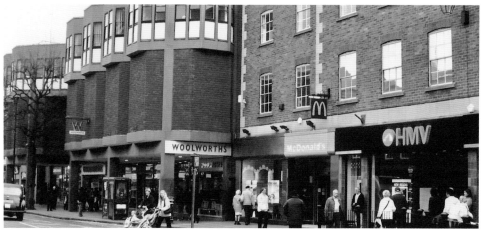

Classic Site in 2007.

Chester Theatre Club

Although the Chester Theatre Group was set up during 1944, it was originally a school built in 1840 and attached to Christ Church. It was closed and sold to Chester Theatre Club in 1962 and is now known as The Little Theatre. Situated in Gloucester Street, Newtown, and run by the group, being self sufficient, they perform six productions every year. So as we highlight the theatres, cinemas and entertainment venues that have disappeared from Chester's streets, it is nice to highlight a successful live theatre in the city and only a 10-minute walk from the station.

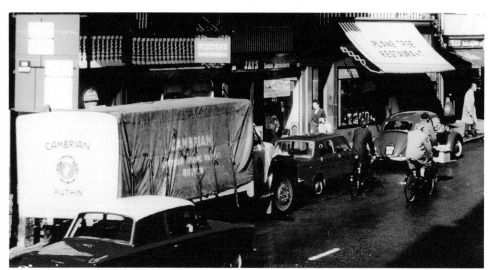

Bridge Street with Plane Tree Restaurant, 1961

Yet again a company that hit the buffers in the 1960s and was no more, giving it its full title the Plane Tree Restaurant and tea lounge. This company was launched in Bridge Street in 1950 and was dissolved in 1961 so the photograph will have been taken when it was closed or shortly to be so; it provides a good excuse to show this photograph that is filled with 1960s charm. There is the Cambrian Mineral Water lorry from Ruthin. This company drew the water for the pop from a local spring. It was later bought by Greenall Whitley, changed hands and still exists, but with a head office in London. Jays House Furnishings can be seen at street level and above it one of Chester's famous rows.

Chester's Train Stations, Chester FC and Final Thoughts

Historically, Chester General station was a joint station between the Chester and Holyhead railway, the Chester and Crewe railway, and the Birkenhead railway. Later, these became the London and North Western Railway (LNWR) and the Great Western Railway (GWR). The joint station dates from 1848, replacing at least two earlier termini of the railway companies concerned.

Chester General Station with Engine Number 45577 'Burma'

Chester railway station is the main station in the city and can be found in Newtown, situated to the north east of the city centre. From 1875 to 1969, the station was known as Chester General station in order to distinguish it from Chester Northgate, although locally the name Chester General is still used. This station was featured in *Chester in the 1950s*; suffice to say it is now the only station in Chester.

Chester Station, 2014

A modern photograph of the exceedingly impressive Chester station. Worth a mention is the small plaque commemorating Thomas Brassey, one of the world's greatest railway building contractors in the early to mid-nineteenth century, which can be seen on the wall opposite the booking office. Thomas Brassey was born at Buerton, on what is now the Eaton Estate, some six miles south of Chester, so we can highlight another Chester worthy here. Not Chester born but worthy of note is John Thomas; in the middle seven bays of the central section can be seen his carvings in stone. He was also responsible for carvings on Buckingham Palace and the Palace of Westminster. Below is Chester's second station, Chester Northgate, opened on 1 May 1875 and situated where the Northgate Arena sports centre is now.

Chester Northgate in the 1960s

In what many people see as a very destructive report that would have far-reaching effects on Britain's infrastructure, the Beeching Report of 1963, 'Changing Britain's Railways', recommended the withdrawal of all services from Chester Northgate. But, a year later, the station still had fourteen weekly services to Wrexham Central, twelve to Shotton High level, six to New Brighton and an hourly service to Manchester central for most of the day. The goods station closed on the 5 April 1965. The people of Chester, like similar groups nationwide, were not happy with this closure, but despite this, services from Chester Northgate to Wrexham and New Brighton were withdrawn on 9 September 1968. This left quite a large terminus with just an hourly service each day to Manchester. This service paid its way and was not recommended for closure. However, the Chester Northgate station was. To solve this problem, a connection was laid between the former CLC line and the former Birkenhead joint line at Mickle Trafford. With this alteration, trains from Manchester could gain access to Chester General station, thereby removing the need to keep Chester Northgate open. This was completed by 1969 and, on 6 October, 1969 Chester Northgate closed completely and shortly after the tracks were lifted and the station demolished.

Liverpool Road Station in Chester

Chester Liverpool Road was a little known station on the former Chester & Connah's Quay railway between Chester Northgate and Hawarden Bridge. It was located at the junction of Liverpool Road and Brook Lane in Chester. Although a small station on a minor line, it boasted four platforms and a goods yard with sidings. The station was opened on 31 March 1890 by the Manchester, Sheffield and Lincolnshire railway (which was renamed Great Central Railway in 1897). This was at the same time as the line was constructed.

The station had an island with two adjacent side platforms because it served two routes. Services from North Wales or Seacombe, with its ferry connection to Liverpool, could either terminate at Chester Northgate station, which was the Chester terminus of the Cheshire Lines Committee, or continue on the line through to Manchester Central. The through lines, which linked Dee Marsh junction to the CLC route to Manchester, passed to the north of the island platform, whereas the branch lines that ran to Chester Northgate went to the south of the island platform. Passenger services ceased on December 1951. The station was completely closed on 5 April 1965 and demolished in the 1970s. The site then became a coal yard. In the 2000s, the area was completely redeveloped for a fitness centre.

Blacon Station

Also on this line and closing in the 1960s could be found Blacon station, which opened on 31 March 1890. A return to Chester Northgate station would cost 6d compared to a bus fare of 9d return. Despite being a busy station, British Railways closed it to passengers on 9 September 1968 as part of the Beeching Axe for the so-called economic modernisation of the British railway network in the mid-1960s.

As we near the end of this look at Chester in the 1960s, let us first have quick look at Chester's football club. This will be followed by another Chester street and we will see what companies' vehicles and shops are there.

Chester FC (Football Club)

Although Chester is one of England's cities, it never seems to have done well in the field of football, but deserves a mention – especially as its fortunes seemed to be improving in the 1960s. The club was founded as Chester FC and joined the Football League in 1931. Over the next eighty years, it spent most of its time competing in the lower divisions.

Its original ground was Sealand Road from 1906 to 1998, when the club went into administration. The 1960s saw the start of the successful post-war period, with South African Peter Hauser joining the team as manager. This lead to the most exciting season for Chester FC. All five forwards managed to score over twenty goals and the club scored 119 in total. Chester's luck did not, however, change; the club was not promoted. In 1983, the club's name was changed to Chester City and it stumbled on through the following years of controversy and arguments. They are now in the Conference League and playing at The Deva Stadium.

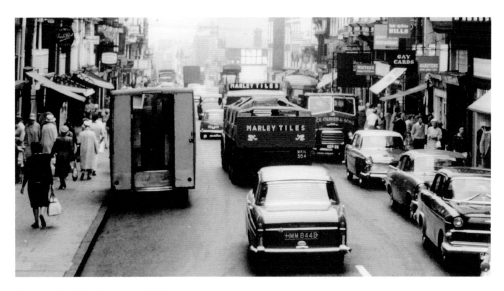

Lower Bridge Street, 1965

Here is another photograph of Lower Bridge Street, taken circa 1965. In the foreground there is an Austin Cambridge that is quite new, having been registered between 1 January and the 31 December 1964. Parked on the right we have a Vauxhall Victor, a Vauxhall Velox and another Austin, but what of the wagons? The Marley Tiles one going away from the camera could have been quite local. The Marley Tile company was based in Sevenoaks in Kent. Early in the 1920s, a man by the name of Owen Aisher, who worked as a house builder, was making doors and windows for his own use and for sale to others using the name Marley Joinery Works. By 1924, he had begun to make concrete roof tiles and, in 1926, his company was established as the Marley Tile Co. The company expanded rapidly; in the 1950s he had factories around the country and opened a further three including one at Delamere near Chester. This was built in the middle of Delamere Forest near to Delamere railway station and manufactured mainly roof tiles. Although the company still exists, the Delamere factory closed in 2007.

One of the company premises in the photograph is that of Will R. Rose, with its sign high up on the left. This was a famous Chester photographic company that had other shops, but the main one was in Chester. It was incorporated on 5 July 1933 and the company was dissolved on 5 March 1996. I know that some of the photographs in this book will have been developed by Will R. Rose – why it was dissolved I don't know, but I suspect that the digital age left it behind, although I may be wrong. In its later years, it was involved in developing photographs sent through the post.

Another shop with its name proudly displayed would perhaps not have the same connotation as it would have today: Gay Cards. This photograph looks the opposite way to the one earlier in the book with the Plane Tree Restaurant in the picture. The sun blind that can be seen on the right under the Gay Cards board also has the sign Plane Tree above it.

There was so much for Chester's tourists to see and do, from the excellent Grosvenor Museum, the Roman remains by Newgate, the ancient pubs, the Rows and of course the walls – something for everyone in the 1960s and today.

Final Thoughts

Who comes from this ancient and revered city? On 2 March 1968, the future James Bond actor Daniel Craig, from Liverpool Road, was born. Gerald Cavendish Grosvenor, The Duke of Westminster, was born here on 22 December 1951. Lucy Meacock from Granada TV was born in London, but moved to Chester when she was six, so can arguably claim to be a Cestrian – especially as I believe she still lives there. Tom Rolt, or, as he was known, L.T.C. Rolt, (Lionel Thomas Caswall Rolt), a name well known to those interested in railways, waterways and industrial history, for the many excellent books he has written on the subjects, especially the canals – was born here on 11 February 1910. There were also, of course, the footballers who were born here and went on to play for teams across the world. Chester also has, for the delectation and enjoyment of tourists, a reconstructed Roman street. A military museum, a toy and doll museum, the Grosvenor Museum and the whole of Cheshire's antiquarian places of interest are within a short distance.

So enjoy this book with its photographs of Chester in the 1960s and the upheaval that it suffered when the inner ring road was constructed. Peruse the photographs of those places that have now been consigned to the history books. A town as ancient as Chester has to be brought up to date; the planners of the 1950s and 1960s did not do a bad job. They had the arguable benefit of not suffering damage to the extent of other towns and cities, and although they had to demolish some beautiful Georgian buildings, they left Chester as we now see it – a Roman town that is worthy of being called one of the most beautiful cities in the country, sitting up there alongside York, Stratford-upon-Avon and London.

This change took place mainly in the 1960s and some of what Prince Charles would call carbuncles, built in those far off days, are being altered or demolished altogether. Well, one of his proudest titles is Earl of Chester, so he must know! Chester welcomes tourists and visitors from far and wide to stay and enjoy what is on offer. Whether you stay in the five-star Grosvenor Hotel or one of the more affordable bed and breakfast establishments, a pleasant sojourn in the city is guaranteed, just as it was in the 1960s, when you had the benefit of travelling here on a train pulled by a big black, green or red steam engine. Or maybe you could travel by canal boat into Chester's centre. While travelling, you may read a book written by Cestrian L.T.C. Rolt, such as his seminal book on the canals *Narrow Boat*. What a way to finish this look at Chester in the 1960s – not many of our towns and cities, other than those flattened in the war, have gone through so much change in such a short period but retained the character that was there before. Enjoy.

Author Information

Paul Hurley is a freelance writer, author and member of the Society of Authors. He has a novel, newspaper and magazine credits, and lives in Winsford, Cheshire with his wife Rose. He has two sons and two daughters.

Contact www.paul-hurley.co.uk

Also by the Same Author

Fiction
Waffen SS Britain

Non-Fiction
Middlewich (with Brian Curzon)
Northwich Through Time
Winsford Through Time
Villages of Mid Cheshire Through Time
Frodsham and Helsby Through Time
Nantwich Through Time
Chester Through Time (with Len Morgan)
Middlewich & Holmes Chapel Through Time
Sandbach, Wheelock & District Through Time
Knutsford Through Time
Macclesfield Through Time
Cheshire Through Time
Northwich Winsford & Middlewich Through Time
Chester in the 1950s